PHOTOGRAPHY

PHOTOGRAPHY

PETER LAYTIN

ILLUSTRATIONS BY MICHAEL FERREIRA

Focal Press is an imprint of Butterworth-Heinemann.

A member of the Reed Elsevier group

No part of this publication may be reproduced, stored in a retrieval system, or transmitted, in any form or by any means, electronic, mechanical, photocopying, recording, or otherwise, without the prior written permission of the publisher.

Recognizing the importance of preserving what has been written, it is the policy of Butterworth-Heinemann to have the books it publishes printed on acid-free paper, and we exert our best efforts to that end.

Library of Congress Cataloging-in-Publication Data

Laytin, Peter.

Photography: creative camera control / Peter Laytin.

p. cm.

Includes index.

ISBN 0-240-80135-0: (alk. paper)

1. Photography—Amateurs' manuals. I. Title.

TR 146.L35 1993

771.3'2 - dc20

British Library Cataloguing-in-Publication Data

A catalogue record for this book is available from the British Library.

Butterworth-Heinemann 80 Montvale Avenue Stoneham, MA 02180

10987654321

Printed in the United States of America

This book is dedicated to my students, past and present, and to the memory of my parents, Sylvia and Bernard, who offered me choices and opportunities from which to grow.

I would like to recognize and thank the following individuals:

acknowledgments

Lynn and Alexander, who know all too well what this project entailed. Nancy Witting, whose friendship and dedication to this book enabled the structure and concepts to become clear. Lynn Sternbergh, for the design that made the text come alive. Donna Gordon, Dorothy Richard, and Joseph Stewart, who helped me get started. Fitchburg State College, Dr. V.J. Mara, the FSC Foundation, Image Systems, the FSC Press and James Roger, for their support throughout this project. Jim Stone, Jim Haberman, Charles Meyer, Jim Sternbergh, Gerard and Paul Sanford at Sanford Camera Repair, Bill Gavin, for professional and technical assistance. Sharon Falter and Karen Speerstra, who saw the need, showed great patience, and pushed at the appropriate times. George Gambsky, who lit the candle, and Minor White, who shared his knowledge, quests, generosity, and friendship.

Finally, I would like to extend my deep gratitude to Michael Ferreira for his dedication and thoughtful, clear, and creative illustrations, which complement the text. I deeply appreciate his commitment to this project.

contents

CHARTS AND DIAGRAMS

1	INTRODU	ICTION

chapter 🚽 3	THE 35 MM CAMERA	
4	Single-Lens Reflex (SLR) and Rangefinder Cameras	
9	Loading and Rewinding Film	
	Manual Load Cameras	
	Auto-Load Cameras	
	Checking Proper Film Loading	
	Setting the Film Speed	

- Rewinding

 13 The Camera Body
- 15 The Shutter
 Focal Plane Shutter
 Leaf, Iris, or Between-the-Lens Shutter
 Shutter Speed Stops

chapter 9 19

LENSES

- 19 Focal Length
- 20 Autofocus Lenses

21 Lens Types

Normal Lens

Wide Angle Lens

Telephoto Lens

Zoom Lens

Portrait Lens

Macro Lens

Teleconverter

- 25 Lenses and Perspective
- 25 F-Stops

29

chapter 6

THE METER SYSTEM

- 29 Reflective Versus Incident Metering
- 30 Types of Meter Sensing
- 31 Meter Displays
 Manual Setting
 Automatic Setting

chapter 1 33

CREATIVE CONTROL VIA HALVES AND DOUBLES

- 33 The "Stop"
 Controlling Exposure: Shutter Speeds and
 - Reciprocity Law
 Equivalent Exposures

F-Stops

34

36 Creative Control–The Exposure Combination

The Shutter Speed Choice
The Three Factors Controlling the
Depth-of-Field
Ways to Use the Depth-of-Field Scale
Advanced Depth-of-Field Control

chapter 51	FILM
J 51	Film Structure
52	ISO/ASA/DIN
53	High Versus Low ISO/ASA
54	Film Speeds: Halves and Doubles
<i>55</i>	Purposeful "Over" and "Under"
	Exposure
	Exposure Compensation Dial
56	Film Characteristics
chapter 6 57	LIGHT CONCEPTS AND CREATIVE
0	CONTROL
57	Using Directional Light
	Front Light
	Side Light
	Back Light
	Revealing Light
61	Meter Control
	18% Reflectance
	Zone System Terminology
63	Using the Zone System
	One Zone = One Stop
	Overriding the Meter
68	Light Direction Corrections
71	The Flash
	"Sync Speed"
	Dedicated Flash
	Flash Exposure
	Manual Flash Exposure
	Auto-Thyristor
	Bounce Flash
	Through-the-Lens (TTL) Flash Metering
	Red Eye

Flash Shadows

75 Filters

Standard Filters for All Films Filters for B/W Film Filters for Color Film Filter Factors

chapter -

5 FINAL TIPS

85 Batteries

86 Three Tips for Hand Holding Shots

Body Tripod

Breathing

Shutter Release Squeeze

88 Lens and Camera Care

89 Film and X-Rays

89 Changing Film in the Middle of a Roll

90 Labeling Film

91 Reciprocity Failure and Correction

92 Rule of f/16

92 Infrared Photography

92 Pushing Film

93 Suggestions For Unusual and Low Light

Exposures

Television Screen Photography Low Light, Firelight and Moonlight Exposures

95 Flash-Fill

97 APPENDICES

105 GLOSSARY

117 INDEX

charts and diagrams

	RANGEFINDER AND SLR CAMERA COMPARISONS
17	CHART 2 SHUTTER SPEED STOPS
26	CHART 3 STANDARD F-STOPS
28	CHART 4 ONE STOP RELATIONSHIP BETWEEN HALF STOPS
34	CHART 5 EQUIVALENT EXPOSURES

- 36 CHART 6
 EQUIVALENT EXPOSURE COMBINATIONS
- 39 CHART 7 SHUTTER SPEED RATES

5

CHART 1

- 52 CHART 8
 ISO/ASA/DIN EQUIVALENTS
- 53 CHART 9
 ISO/ASA FILM SPEEDS
- 53 CHART 10 ISO CHARACTERISTICS

63	CHART 11 DESCRIPTION OF ZONE VALUES		
64	CHART 12 INTERRELATIONSHIP OF ZONES AND STOPS		
79	CHART 13 NEUTRAL DENSITY FILTERS		
80	CHART 14 BLACK AND WHITE FILTERS		
83	CHART 15 FILTER FACTORS		
91	CHART 16 RECIPROCITY CORRECTIONS FOR BLACK AND WHITE FILM		
94	CHART 17 LOW LIGHT EXPOSURES (ESTIMATED)		
4	DIAGRAM 1 SLR/RANGEFINDER CAMERAS		
6	DIAGRAM 2 SLR / MIRROR PRISM		
8	DIAGRAM 3 CAMERA BOTTOM		
8	DIAGRAM 4 CAMERA INTERIOR (BACK OPEN)		
11	DIAGRAM 5 FILM CASSETTE		
15	DIAGRAM 6 FOCAL PLANE SHUTTER		
16	DIAGRAM 7 IRIS SHUTTER		
20	DIAGRAM 8 FOCAL LENGTH OF LENS		
21	DIAGRAM 9 LENS FOCAL LENGTH AND ANGLE OF VIEW		

- **DIAGRAM 10** F-STOP RELATIONSHIP
- **DIAGRAM 11**METER DISPLAYS
- 41 DIAGRAM 12
 CIRCLES OF CONFUSION
- **DIAGRAM 13**DEPTH-OF-FIELD SCALE (NORMAL LENS)
- **DIAGRAM 14**DEPTH-OF-FIELD SCALE (ZOOM LENS)
- **DIAGRAM 15**FACTORS AFFECTING DEPTH-OF-FIELD
- **DIAGRAM 16**DEPTH-OF-FIELD: F/8 AND F/22
- **DIAGRAM 17**HYPERFOCAL FOCUSING (AT F/16)
- **DIAGRAM 18**ZONE FOCUSING
- **DIAGRAM 19** FILM
- **DIAGRAM 20**EXPOSURE COMPENSATION DIAL
- **DIAGRAM 21**CONTINUOUS TONE GRAY SCALE
- **DIAGRAM 22**ZONE SYSTEM SCALE
- **DIAGRAM 23**POLARIZING FILTERS

introduction

Photography: Creative Camera Control is for beginning and intermediate photographers, and for those who have recently acquired a camera. Showing the inexperienced photographer how to gain control, make creative decisions from a foundation of knowledge, and increase self-confidence is the motivating force behind this book. In an easy-to-follow narrative, this step-by-step approach to photography will lead the photographer those few critical steps from understanding the inter-relationship of all aspects of camera, lens, and film, to a level of growing confidence that allows for creative decision-making.

For new camera owners who are frustrated by their camera manuals, for beginner photographers with no knowledge of camera work, for self-taught photographers, and for those enrolled in photography classes the explanations, diagrams, and charts will be informative and useful in acquiring camera control.

I believe that through "conscious" photography, the creative vision can easily be cultivated. It is far more rewarding to know the potential of the camera, lenses, and film, to

understand how they relate to each other, and to master control of them than it is to occasionally make a great photo due to luck or chance.

Through knowledge and conscious decision-making, an amateur photographer can acquire confidence and creative control over the camera. An understanding of two concepts will allow for unlimited creative possibilities and satisfaction: First, that all aspects of photographic control are related to each other (halves and doubles, explained throughout the book). Second, that one can learn to see and think the way a light meter "sees" the scene. What you will learn in this book will not necessarily allow you to use the camera more quickly, nor magically intuit proper exposures. However, you will learn the possibilities and limitations of each photograph. You will know why each photograph turns out the way it does, and what to do to accomplish a different result.

As cameras become more automated, offering many features and functions, the potential for becoming overwhelmed increases. The result is often the use of only a few features, which might not always achieve the desired result. There are choices, even with automated cameras, that will determine the success of a photograph.

The structure of this book is as close as possible to the teaching method I have successfully used for more than 20 years in introductory photography courses and workshops.

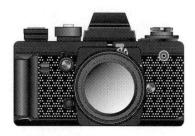

the 35 mm camera

The camera as we know it is derived from the **camera obscura**, literally "dark room." This 15th century device was used as an aid for artists' drawings until the 19th century. In 1837, when it was announced that "nature" could be recorded with a camera, the invention of photography was official.

From the bulky and cumbersome early view-cameras to the extremely sophisticated 35 mm roll-film cameras of today, photography and the camera have continued to evolve. First introduced in 1925, the 35 mm camera is now the most popular size roll-film camera today, used by amateur and professional photographers alike.

Any camera is basically a light-tight box with a lens, which is often in a focusing mechanism. The lens has an aperture that controls the amount of light entering the camera. Light-sensitive film is held in place at the rear of the camera, opposite the lens, and is secured to a film advance mechanism. A shutter controls the duration of the light exposure, and a viewfinder

allows for both composition and (in more sophisticated cameras) focusing.

format

Cameras are often grouped according to their format (the format is the negative size produced by the camera). Cameras are also classified by their design or optical viewing systems. Simple cameras (those with one set focus or those with two or three pre-set distances to choose from) are simply called "viewfinder cameras." Sophisticated 35 mm cameras (those that allow for variable focus) are called either single-lens reflex (SLR) or rangefinder cameras.

single-lens reflex (SLR) or rangefinder

SINGLE-LENS REFLEX (SLR) AND RANGEFINDER CAMERAS

DIAGRAM 1 SLR / **RANGEFINDER CAMERAS**

The simplest way to identify a single-lens reflex camera is to look for a bulge on the top center of the camera, which houses the viewfinder. The viewing system of a single-lens reflex camera is composed of a reflex mirror housed in the camera body, and a prism and focusing screen housed in the viewfinder. The rangefinder. which is flat across the top, uses a combination viewfinder (for composing) and simple prism (for focusing), located above and usually to the side of the lens.

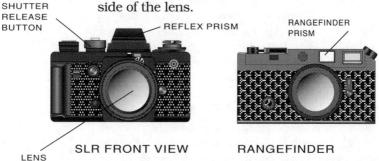

Single-lens reflex and rangefinder cameras each have advantages and disadvantages. One is not inherently better than the other. Many people believe that the single lens reflex (SLR) camera is superior because it allows you to look directly through the lens, while the rangefinder forces you to look at the prospective picture through a window off to the side of the lens. While it is true that the rangefinder camera is often at the lowend of a manufacturer's camera line, some of the finest engineered and most optically advanced cameras are rangefinders.

SLR	RANGEFINDER	
Through-the-lens composition (accurate composition) Effects of various lenses visible Accurate close-up copystand photography Numerous lens choices	Less internal vibration (hence, inherently sharper)	RANGEFINDER AND SLR CAMERA
	Constant visual contact	COMPARISONS
	Quieter shutter Bright viewing system Fewer moving parts Flash sync at any shutter speed (if leaf	
	shutter)	ADVANTAGES
Increased internal vibration Loss of visual contact during exposure Louder shutter Dim viewing system More moving parts Flash at sync speed or slower	Viewfinder composition (less accurate composition)	DISADVANTAGES
	Effect of lens changes not visible	
	Parallax error in close-up/copy-stand photography	
	No interchangeable lenses (some models)	

Advantages and Disadvantages

Inside the single-lens reflex camera, a mirror is positioned at approximately a 45° angle to the lens. This mirror reflects the light coming through the lens, directing it to a focusing screen and prism system at the top of the camera, where the image is reproduced right

mirror

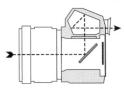

MIRROR DOWN

MIRROR UP

DIAGRAM 2 SLR / MIRROR PRISM side up. In order to expose the film that is located directly behind the mirror (and shutter), the mirror must flip up, out of the way. After exposure, the mirror flips back down to its original position. This moving mirror creates a residual internal vibration at the moment of exposure, which may slightly diminish the sharpness of an image (when compared to a rangefinder).

When looking through the eyepiece of a rangefinder camera, you are looking through a window above and usually to the side of the lens. There is no internal "moving" mirror system for viewing. Therefore, there is no internal vibration at the moment of exposure. A photograph from a rangefinder is inherently sharper than one from an SLR if all other variables are equal (i.e., engineering, optics, etc.).

When using different focal length lenses with the SLR, you can see the changes those different lenses create. This is because you are looking through the lens of the camera. Whatever you see through that lens is what will be recorded on the film. So, "what you see is what you get" with an SLR.

The rangefinder does not allow the same degree of composition control. Some high-quality rangefinder cameras allowyou to change lenses, but the system for viewing and composing an image remains unchanged. When looking through the eye piece you are still using the viewing system built into the camera body. Different focal-length lenses create different magnifications and spatial distortions, but you cannot see those changes. Therefore, you cannot compose accurately for them. You are changing the "taking" lens, the lens that records the picture, but you are not changing the lens in the viewfinder!

A good rangefinder camera with interchangeable lenses has a mechanism inside the viewfinder to guide you in composing, such as LED brackets that change position according to the lens. This mechanism gives a general parameter within which to compose, but again, it does not allow you to see distortion or changes in spatial relationships.

With rangefinder cameras, the viewing system can create another type of composition problem: "parallax error" in close-up and copystand photography. What your eye sees in the viewfinder will be different from what the lens will record when focused on a subject less than 5 or 6 feet from the camera. An object that is centered in the viewfinder is actually recorded off-center on the film. The closer an object is to the lens, the more severe the problem. The only way to correct for parallax with a rangefinder camera is to guess how much to move the camera to properly center the subject for the "taking" lens. A rangefinder camera is therefore not the best choice for doing close-up or copystandwork, situations where composition placement is critical.

There is no parallax error with an SLR. Again, what you see in the viewing system is what you get on the film.

SLR systems offer a great variety of lens choices, both from the camera manufacturer and from after-market lens manufacturers. Rangefinder cameras that allow interchangeable lenses are usually restricted to just the manufacturer's lens system.

With an SLR, the mirror is up for the fraction of a second when an image is recorded, blacking-out the viewing system. With a rangefinder camera one is able to maintain constant visual contact, even during the exposure. Some photographers say they prefer the rangefinder to the SLR because of the loss of eye contact at the exact moment of exposure. However, for these few individuals, such reasoning may be philosophical rather than practical.

The SLR is a noisier camera. With the mirror flipping up and down, in addition to the

parallax error

DIAGRAM 3 CAMERA BOTTOM

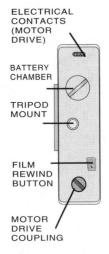

DIAGRAM 4
CAMERA
INTERIOR
(BACK OPEN)

snapping sound of its focal plane shutter (discussed later), the SLR is quite loud. The rangefinder camera, on the other hand, with no mirror to move, is relatively quiet. A photographer who needs to work inconspicuously in a crowd is far more obvious with an SLR. After just one shot -*CLICK* - everyone is aware of the photographer's presence. Some photographers and photojournalists prefer a rangefinder camera because it makes them less noticeable. It's a matter of choice and working style.

Another advantage of the rangefinder camera is that it usually has a brighter viewfinder than the SLR camera. This is especially advantageous in low-light situations.

An SLR has more moving parts than a rangefinder camera. Its moving mirror system must be perfectly timed to the opening of its shutter. With the SLR, therefore, there is greater potential for camera problems and repairs.

In flash photography, the SLR has a specific "sync speed." The camera cannot be used at a shutter speed faster than the "sync speed." However a rangefinder camera with a leaf-shutter can use any shutter speed for flash photography. (See pg. 71.)

Clearly, there are a number of considerations involved in choosing a 35 mm camera

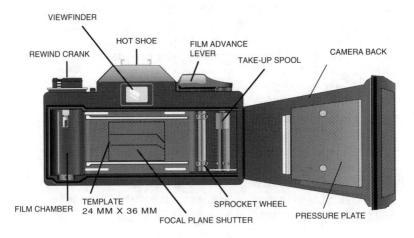

system. One system is not "better" than the other, except in terms of your own personal preferences and working style.

LOADING AND REWINDING FILM

The film for 35 mm cameras comes in a metal, light-tight cartridge called a "cassette". The film feeds from the cassette through a felt light trap. Although the film measures 35 mm wide, the actual size of each negative is $24 \text{ mm} \times 36 \text{ mm}$. The half-width of film at the beginning of a roll is called the "leader" of the film.

cassette

In some cameras, raising the rewind crank post opens the camera back and allows the film to be placed in the film chamber. If you have to raise this post to get the film into the film chamber, then you need to lower it again to secure the cassette. Automatic winding and auto-load cameras may not have this type of post. In these cameras, the cassette slides in from the open bottom end of the film chamber up onto the post.

rewind crank camera back film chamber

Inside, usually attached to the camera back, is the pressure plate. The pressure plate holds the film absolutely flat against the rectangular window called the 35 mm template, which creates the format size (24 mm x 36 mm) parallel to the lens plane. If the film were allowed to buckle even slightly, the photograph would be out of focus.

pressure plate template

Manual Load Cameras

After placing the cassette in the film chamber, stretch the leader across the template, then across the sprocket wheel and onto the take-up spool. When you advance the film, the sprocket wheel pulls fresh film forward and the take-up spool winds the film. Advance the film with the film advance lever once or twice, until you get past the film leader. Make sure the

sprocket wheel take-up spool

sprocket wheel

sprocket wheel is engaging the sprocket holes on the film. Close the camera back.

Auto-Load Cameras

Secure the film in the film chamber. Stretch the leader across the template, then across the sprocket wheel and up to the designated mark in your camera body. Close the camera back. The film will automatically advance to the appropriate position.

Checking Proper Film Loading

When the film is properly loaded in a manual camera, the film rewind crank should move counter-clockwise every time the film is advanced.

Manual Load Cameras

After loading film and closing the back of the camera, advance the film once. This will reengage the sprocket wheel. Now, gently rewind the film, without using the rewind release button (see pg. 12). This will take up any film slack in the cassette. As soon as you feel resistance (from the tightened film against the engaged sprocket wheel), **STOP** rewinding. With every film advance you should now see the film rewind crank move, as fresh film is pulled from the cassette. If the rewind crank is not moving, the film is not being pulled through the camera. Open the back to check whether the film has slipped off the take-up spool. Try loading it again.

Auto-Load/ Rewind Cameras

Most motorized auto-load/wind/rewind cameras have a window to give you a visual clue for proper film loading. Check your specific manual.

Setting the Film Speed

exposure meter

Most cameras have a built-in exposure meter (see pg. 29) that calculates the intensity of the light and determines an appropriate exposure for the type of film you are using. (See "Film".) All film is standardized by a film sensi-

tivity number designated by the International Organization of Standards (ISO). This is the same numbering system used by the defunct American Standards Association (ASA). In older cameras, you must set the camera's meter to the sensitivity of the film you are shooting. There is usually a small dial containing the ISO settings.

Recent advances in manufacturing have made cameras able to sense the film cassette's DX bar code, a combination checkered and bar code (see Diagram 5). When the DX code is electronically read by the camera's sensors, the ISO (ASA) film speed is automatically set for the meter system. Depending on the camera, the DX sensor might also enable the camera to signal the last shot, or automatically rewind the film after the last frame. Sophisticated DX sensors know whether the film being used is color or black and white, and allow for more difficult exposures with black and white film (black and white film has more latitude and is more forgiving than color film).

If you *manually* set the ISO (ASA) it must be re-set every time you change to a different speed film. Forgetting to reset the ISO is one of the most common mishaps in photography.

ISO

ASA

DIAGRAM 5 FILM CASSETTE

DX BAR CODE

Rewinding

If you accidentally open a camera back without rewinding the film, light will expose and ruin the film. If this happens in a bright light environment, the film will have light leaks coming in from all edges, and will not be worth processing. (No matter how fast you close the camera back, you probably won't react faster than the speed of light!) But, if this accident occurs in a low-light situation, you react quickly in closing the camera back, and you are at the end of the roll of film, you might save the first few shots on the roll. This is because they may have been protected by the multiple revolutions of film around them. If the film is important to you, it might be worth it to go ahead with processing.

must rewind the film back into the light proof cassette. Remember, the film is unprotected when it is outside the light proof cassette on the take-up spool.

manual rewind crank

auto-rewind switch

rewind release button You must rewind the film back into the cassette with the manual rewind crank (on auto-wind cameras, with the auto-rewind switch). Some auto-wind cameras rewind automatically after the last frame is exposed.

At the end of shooting a roll of film, you

Before you begin rewinding film on a manual camera, you must depress or activate the rewind release button (sprocket wheel release switch), which releases the sprocket wheel gear from the forward direction. Trying to rewind without releasing the sprocket wheel would tear film between the sprocket holes by ripping it across the geared, stationary sprocket wheel. These tiny chips of film could then cause serious problems to the shutter mechanism.

On most cameras the rewind or release button is located directly below the sprocket wheel, on the bottom of the camera body. On some cameras it may be a lever located on the top or front of the camera body. The rewind post should remain down and engaged inside the cassette. The rewind crank usually has an arrow showing the rewind direction.

Motorized cameras have a switch for automatic rewind, which releases the sprocket wheel before rewinding. Some cameras automatically dump the film onto the take-up spool when the film is initially loaded and the camera back closed. Then, with each exposure, the film is automatically rewound back into the cassette.

With manual cameras, it is best to rewind the film slowly to avoid static build-up. This is especially true when you're in a cold or dry environment. Since the film is rewinding across a metal pressure plate and through the felt strips of the cassette, static charge can build up. The faster you rewind the film, the more

likely this is to occur. Too much static build-up can create a discharge that looks like single or multiple streaks of lightning across the film. These streaks can occur anywhere on the film - across frame lines, between sprockets, and on the image areas. In extreme cases, static discharge can ruin an entire roll. Of course, if you have automatic rewind, you will not be able to control the rewind speed. Therefore, try to "ground" the camera, or your body, before rewinding. Touching the camera or a bare hand to an object that is grounded, like a piece of metal, or even touching snow-covered ground, will help prevent static discharge. If the camera is very cold, wait until you are indoors and the camera is at room temperature before rewinding the film.

THE CAMERA BODY

Many SLR cameras have a depth-of-field preview button or manual switch. This switch allows you to look through the lens aperture (f-stop) that will be used at the moment of exposure. When you look through an SLR camera's viewfinder, you look through the largest possible f-stop opening for that lens, no matter what f-stop is set. At the moment of exposure it closes to the selected f-stop; after exposure it returns to the largest f-stop. You will not experience seeing the selected f-stop unless you preview it.

The shutter release button is depressed to take or "receive" the photograph. A cable release can usually be screwed into the shutter release button for use in conjunction with a tripod. A cable release triggers the shutter release internally, without any physical movement or pressure on the camera. On the bottom of the camera, a female screw thread called a tripod mount can usually be found for attach-

depth-of-field preview button or manual switch

shutter release button

cable release

tripod

tripod mount

ing the camera to a tripod. A tripod is a threelegged support for a camera that can stand on the ground, the floor, or a table top. It is used when you want the sharpest shot possible or when you need to keep your hands free for other things. At very slow shutter speeds, it is difficult to hold a camera steady.

shoe

hot shoes

Another feature on many cameras is the shoe, located on top of the camera. The flash unit attaches to the camera by sliding onto this shoe. Most shoes are called hot shoes because they have small contact points that connect the electrical circuitry of the camera to the flash. This contact allows the flash to fire when the shutter release button is depressed. There may also be other contact points on the shoe that allow "dedicated" flash. (See pg. 71.) Many cameras come with a flash built into the camera body: these have no shoe.

sync cord

sync terminal

self-timer

If the flash unit is too large to fit on the hot shoe, or if you want the light to come from a direction other than the camera position (for possibly an aesthetically more appealing light), then a special sync cord (PC cord) must be attached from the flash unit to a separate synchronization (sync) terminal on the camera body, or to an adapter that attaches to the hot shoe. Electric current must trigger the flash when the camera's shutter release button is depressed.

Some cameras have a self-timer that automatically releases the shutter internally, after a set time delay. The self-timer is often used when the photographer wishes to get into the photograph. It is also used to avoid hand holding a camera when a slow shutter speed is used and a tripod or cable release are unavailable. The camera can be placed on a ledge, table-top, or any available level surface, and the self-timer will release the shutter without excessive camera movement.

film-advance lever

Manual wind cameras have a film-advance lever for advancing film to the next frame,

auto-wind

but most cameras today are motorized (autowind), which eliminates the need for a film advance lever. The film advance lever or autowind mechanism accomplishes three things. First, it moves the take-up spool and sprocket wheel, pulling fresh film forward. Second, it changes the number in the film counter window. Third, and most importantly, it cocks or resets the shutter. (Older manual cameras allow for supplementary motor drives, which provide rapid film advance and shutter cocking for multiple frames-per-second shooting.)

THE SHUTTER

The shutter controls the amount of light that strikes the film by opening for a specific length of time. It can be controlled electronically, mechanically, or (with some cameras) both electronically and mechanically.

shutter

Focal Plane Shutter

speeds.

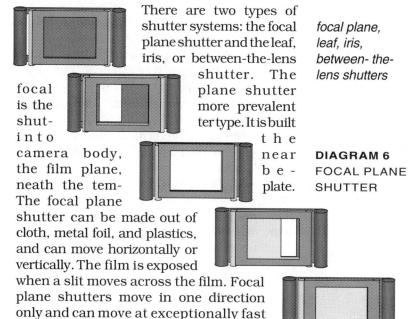

DIAGRAM 7 IRIS SHUTTER

IRIS, CLOSED

IRIS, PARTIALLY OPEN

IRIS, OPEN

IRIS, PARTIALLY CLOSED

IRIS, CLOSED

If you have a manual wind camera, open the back and take a look inside. When you advance the film and cock the shutter, you will see two sets of overlapping screens move either vertically or horizontally from a resting position to the opposite side of the rectangular template opening. When the screens move from one side of the window (at rest) to the other side of the window (cocked), the shutter is ready to be released. When you depress the shutter release button, the two screens will separate: the first screen releases and moves back to rest, creating a gap where light can strike the film, and the second screen follows, closing off the opening. You control how quickly the second screen follows the first by setting the shutter speed controls. To see the difference in shutter speeds, look through the back of the camera with the back open. Set the shutter speed to 1 second and release the shutter, then change to 1/2 second and release the shutter, and so on. continuing up the scale.

Leaf, Iris, or Between-the-Lens Shutter

The leaf, iris, or between-the-lens shutter is built into the lens. It is made of thin metal leaves that open like the iris of an eye, from the center outward, and allows light to strike the entire film surface during the process of opening and closing down. Leaf shutters cannot be engineered to move as fast as focal plane shutters, since they have to open fully and then reverse to close back down. It's usually less expensive cameras, such as disk cameras, that have this type of shutter built into them, but some expensive camera systems also use the leaf shutter. If you open up the back of a camera and see the rear of the lens, you know it has a leaf shutter.

You can control the shutter speed for creative effect, using the shutter speed dial or the shutter mode switch, depending on your

camera. The shutter speed is one of the important variables you should become knowledgeable about, to have full control over your photography.

Shutter Speed Stops

The standard shutter speed settings are actually reciprocals.

CHART 2 SHUTTER SPEED STOPS

SHUTTER SPEED STOPS B 1 1/2 1/4 1/8 1/15 1/30 1/60 1/125 1/250 1/500 1/1000 SLOWER SPEED MORE EXPOSURE FASTER SPEED LESS EXPOSURE

Some cameras are able to go to 1/8000, but I would say 1/8000 of a second is for photographing humming birds hiccupping. The majority of cameras go only to 1/1000. "B" stands for bulb, meaning the shutter will stay open for as long as you have your finger on the shutter release button. "B" is used for long exposures, called time exposures (exposures longer than one second).

Early shutters were triggered by air pressure in a sealed pneumatic cylinder. As the photographer squeezed a rubber bulb, the pressure opened the shutter. As long as the bulb was depressed the shutter remained open. Hence, the term "bulb" or "B."

The shutter speed controls the length of the exposure. Each shutter speed stop halves or doubles the amount of light as the one next to it. For example, 1/500 is half as much light as 1/250, and 1/4 is twice as much light as 1/8. The only adjacent stops not perfectly halving or doubling each other are 1/8 to 1/15, and 1/60 to 1/125.

Manual and semi-automatic cameras *must* be set exactly on a shutter speed stop. Some

"B"

computerized cameras allow shutter speed stops to be set between full stops (e.g., at 1/45), but on manual cameras you can't set your speed between 1/30 and 1/60 and hope to get 1/45!

Every camera should show the shutter speed selected. If you can't move a dial or push a button to choose a shutter speed on your camera, you might be able to move the f-stop ring, thereby creating a corresponding change on the shutter speed scale. This scale would be located inside the viewing system or on top of the camera body. (See the section on the Aperture-priority (AP) system, pg. 32.) If your camera does not provide information as to the choice of shutter speed or f-stop to be used, the amount of creative control you have with your camera is limited.

lenses

2

A lens is a piece of glass or other transparent material made with surfaces that force rays of light to diverge or converge to make an image. A photographic lens is made up of a number of separate lenses, each of which is called a lens element. The lens elements are mounted within a cylinder of plastic or metal called the lens barrel. This barrel has an adjustable focusing ring on it. When an autofocus (AF) lens is mounted on an autofocus camera, a motor, in the lens or camera body will adjust the focusing ring gears. The lens might also have an f-stop ring on it that adjusts the aperture inside the lens barrel. A lens is designated by its focal length. Examples of different focal length lenses include 28 mm, 35 mm, 50 mm, 150 mm, 250 mm. 35-70 mm. 70-210 mm.

lens element

lens barrel focusing ring autofocus (AF)

f-stop ring

focal length

FOCAL LENGTH

The focal length of a lens is the distance from the optical center (rear nodal point) of the lens to the plane of sharp focus for light rays from infinity.

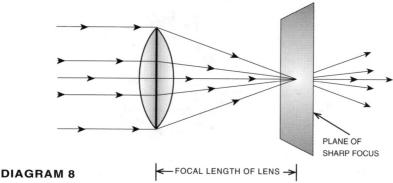

FOCAL LENGTH OF LENS

Different focal length lenses create different effects in your photographs. Basically, the focal length controls *image size or magnification* and *angle of view*.

AUTOFOCUS LENSES

focus-lock

The technology of autofocus lenses is constantly improving, with advancements in the speed of focus, sensitivity in low light and selectivity. The newer lenses generally allow for quick and accurate focusing, but there can be problems. To overcome some of the problems with autofocus systems there is a focus-lock switch. This allows you to focus on a subject of main interest, lock that distance on the lens. and then reframe the composition, moving the main subject off-center. When purchasing an autofocus lens, make sure it has a manual override of the autofocus. It should allow for "smooth" focusing and ease of use, and it should give accurate results. Some autofocus systems focus the lens at the point where the photographer's eye is looking when the shutter button is pressed. Autofocus camera systems now make up the majority of new 35 mm camera sales.

LENS TYPES

In 35 mm photography, lenses with a focal length of 50 mm (40 mm—55 mm) are called normal lenses. Focal lengths greater than 50 mm are called "long lenses," and less than 50 mm, "short lenses". The commonly accepted term for a long lens is telephoto lens. The commonly accepted term for a short lens is wide angle lens. There are also "zoom" lenses, which have a variable range of focal lengths. Zoom lenses are fast becoming the most popular lens in the amateur market.

normal, telephoto, wide angle, and "zoom" lenses

1000 MM

500 MM

Normal Lens

The normal lens for a 35 mm camera is a 50 mm lens. A range of focal lengths, from 45 mm to 55 mm, is also considered normal, but the 50 mm is the most common. Since the eve does not see the way a 50 mm lens sees, why should it be considered a "normal" lens? The human eye sees a peripheral range of about 180°. A normal lens has approximately a 47° angle of view. The normal lens definitely edits out much of what the naked eye sees. The "normal" human eye, when staring at a specific point, keeps that one point sharp; the remaining field of vision increasingly blurs towards the periphery. When a lens focuses on a specific point, let's say 10 feet away, everything on that plane 10 feet away is in focus, from top to bottom, left to right. What is "normal" though, are the objects' sizes and space relationships to each other as they recede in the distance. When I look down a tree-lined country road, there is a certain distance between me and the first tree, the first tree and the second tree behind it, between the second and third tree, and so on. As the trees recede, they appear smaller and smaller. When looking

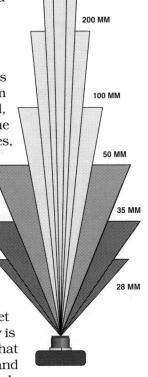

DIAGRAM 9 LENS FOCAL LENGTH AND ANGLE OF VIEW

through a 50 mm lens, the trees will have the same spatial and size relationships to each other as they would to my naked eye. With a normal lens, objects appear as they would to the naked eye, in terms of size and proportion.

Wide Angle Lens

A lens with anything less than a 50 mm focal length is called "wide angle." The standard wide angle lenses are 35 mm, 28 mm, 24 mm, 20 mm. Next, depending on the manufacturer, come 19 mm, 18 mm, 17 mm, and 16 mm, followed by highly specialized and unique wide angle lenses called "fish-eyes." If you own a 50 mm lens, a 28 mm wide angle lens would be a good choice for a wide angle lens. A 35 mm lens is not different enough from the everyday 50 mm "normal" lens to be a popular choice for a first wide angle lens purchase. Many photographers actually use a 35 mm lens as their everyday normal shooting lens. Below 35 mm lenses begin to create dramatic shifts.

Wide angle lenses have a greater angle of view than a normal lens. As you go to an increasingly wide angle lens, your field of view increases, and the scene itself appears to shift farther away from the camera. The wider the angle of the lens, the farther away and the smaller objects will appear. In order to maintain the same size subject with a wide angle as with a normal lens, you need to place the camera closer to the subject.

The major effect of a wide angle lens is the apparent distortion in spatial relationships. An object close to the camera will become abnormally large in size and proportion compared with objects farther away. The wider the angle lens, the greater that apparent distortion becomes.

Telephoto Lens

Telephoto lenses magnify objects and make them appear much closer than they really are. This is because telephoto lenses compress space, bringing objects closer together visually. As the focal length increases, the angle of view (angle of acceptance) decreases, and the distance between objects receding in space is more compressed.

Standard telephoto lenses in 35 mm photography are 85 mm, 105 mm, 135 mm, 200 mm, 300 mm, 500 mm, and 1000 mm. There are disadvantages to extremely long lenses. The longer the lens, the heavier it is, and therefore the more difficult to hold steady. Not only are objects magnified; very slight camera movements are also magnified. A slight movement that might not affect the image from shorter focal length lenses can create a blurred image from a long telephoto lens.

Zoom Lens

Zoom lenses have a varying range of focal lengths. When photographing with a zoom lens, you don't have to be concerned about which focal length is used. While looking through the camera, you move the lens barrel zoom ring (which changes the focal length) in or out until the magnification or angle of acceptance is aesthetically pleasing. The advantage of a zoom lens is in its ease and convenience. It has the ability to provide the focal lengths of many fixed lenses all within one lens. But there are drawbacks. Zoom lenses are often heavier in weight and provide a slower "speed" lens (see pg. 28.) than fixed lenses.

In the zoom lens is a set of moving elements. These moving elements cannot be perfectly positioned for all focal lengths; therefore, a zoom lens is not as sharp as a fixed focal length lens of the same quality. Inexpensive zooms are not worth your time or money. Your photographs will never be crisp and sharp. If you want to buy a zoom lens, take the money that you would have spent on two fixed focal length lenses and put it towards the best zoom

lens you can afford. Look at the zoom purchase as a way to avoid changing lenses in the field, not as a means of saving money. There are many excellent lens manufacturers, and with new computer formula lenses the quality is extraordinary.

Portrait Lens

Many photographers enjoy using a short telephoto lens for portraiture, usually one between 70 mm and 105 mm. Such a lens permits the photographer to be at a slightly greater distance from the subject than with a normal lens. This greater space is more comfortable for many photographers and their subjects, allowing for a more relaxed portrait. Also, the slight telephoto focal length, at close focus, will minimize distortion of facial features in portraits, over the normal lens.

Macro Lens

Macro lenses allow you to photograph within inches of your subject. They allow extreme close-up work, with an object to negative size ratio up to 1 to 1. The lens optics correct for aberrations caused by close focusing distances. Macro lenses have been built into all the categories of lenses, but the most popular macro lenses are the 50 mm and 100 mm lenses, and macro zoom lenses.

Teleconverter

A teleconverter is an inexpensive attachment that fits between the lens and the body of the camera and effectively increases the focal length. The most common teleconverters are 2x and 3x (extenders). A 2x converter will double the focal length; a 3x will triple it. Unfortunately these attachments reduce the amount of light two or three stops (respectively) and introduce aberrations that affect the clarity and sharpness of the lens. A better choice is to

save the money and put it towards a telephoto lens.

LENSES AND PERSPECTIVE

There is a popular misconception that the focal length of a lens controls perspective. However, perspective is controlled only by the distance the lens is from the subject. If a telephoto lens and wide angle lens were used from the same distance from a subject, the perspective would remain the same; only the field of view would vary. The subject would seem farther away in the wide angle shot and closer in the telephoto shot. But if a section of the wide angle shot were blown up to match the telephoto image, the photographs would be exactly the same.

If a telephoto lens and a wide angle lens were used to take a shot of an object, that object would be the same size in the foreground of both photographs only if the wide angle lens were moved much closer to the subject than the telephoto lens. This change of distance would create a dramatic change in perspective between the foreground object and its background. The telephoto lens would compress the space, while the wide angle lens would exaggerate the foreground-to-background distance.

Perspective is controlled only by the distance the lens is from the subject.

F-STOPS

An aperture is the area, or size, of the lens opening regulated by an iris diaphragm. An aperture opening is designated as a mathematical ratio called an f-number. The ratio between the focal length of a lens and the diameter of the aperture opening is a specific f-number or f-stop. It is nothing more than a simple equation: the focal length of a lens divided by the diameter of the aperture.

aperture

diaphragm

f-stop

The f-stop is the focal length of a lens divided by the diameter of the aperture.

Example:

If a 100 mm focal length lens has a 25 mm diameter aperture opening, then it would be calibrated as an f/4.

$$\frac{(100 \text{ mm})}{(25 \text{ mm})} = \mathbf{f/4}$$

A 50 mm lens with a 12.5 mm diameter aperture would also be marked f/4. If that same 50 mm lens had its diameter adjusted to a 25 mm opening, it would then be f/2. The larger the opening, the smaller the f-number.

$$\frac{(50 \text{ mm})}{(12.5 \text{ mm})} = \mathbf{f/4}$$

$$\frac{(50 \text{ mm})}{(25 \text{ mm})} = \mathbf{f/2}$$

At the same f-stop, all lenses admit the same amount of light. If the same f-stop is set on two different focal length lenses, the aperture diameters will differ, but the same ratio will be maintained (see the two **f/4** examples above). An f/8 on a telephoto lens allows the same image brightness as an f/8 on a wide angle lens, and so it is with any f-stop.

CHART 3 STANDARD F-STOPS

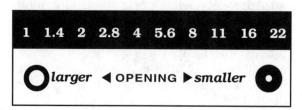

Although these numbers seem haphazard, with no progressive relationship to each other, each is actually the previous number multiplied by the square root of 2.

Like shutter speed settings, each f-stop setting halves or doubles the amount of light as the next f-stop setting. This is important to understand. F/8 lets in twice as much light as f/11, and f/2.8 is half as much light as f/2. Halfway between one f-stop to halfway between the next f-stop is also one full stop, or halving and doubling (see Chart 4, page 28). Unlike shutter speeds, f-stops can be set anywhere between the full stop markings, whether or not there are physical click stops. Computerized cameras show the in-between stops on the screen readout.

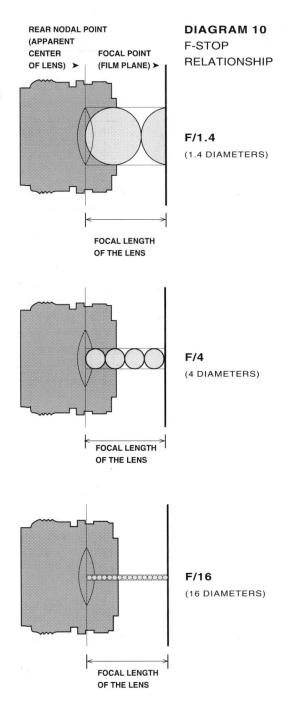

CHART 4 ONE STOP RELATIONSHIP BETWEEN HALFSTOPS

(See Appendix 3, page 98)

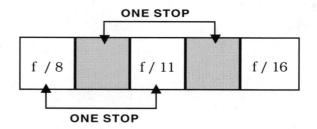

Speed of a Lens

The largest possible f-stop opening of a lens is called the "speed" of a lens, or "maximum effective aperture." An f/1.4 is a "faster" lens than an f/2, because it admits more light and therefore permits a faster shutter speed (hence "speed of a lens"). A "fast" lens costs more than a "slow" lens, if all other factors are equal (i.e., same focal length, manufacturer, etc.). Unless you plan to do a lot of low light photography without using a flash or other additional light sources, buying a "fast" lens is usually not worth the additional investment.

the meter system

3

When loading film, it is imperative to set the proper film speed on the camera to correctly cue the internal light meter. An automatic camera with DX sensor will take care of this automatically. If you are using a separate, hand-held light meter, the meter will have to be set to the speed of the film in your camera. The light meter, whether built into the camera or hand held, will determine the correct exposure by analyzing the existing light in relationship to the film sensitivity. The meter will then set or determine the f-stop and shutter speed combination to be used.

REFLECTED VERSUS INCIDENT METERING

The built-in camera meter is a reflected-light meter, one that reads the light reflecting off or emitted from the objects in the field. This reflected light is called "luminance." The reflected-light metering system allows metering from the camera position. With hand-held meters there is usually a choice of reflected-light or incident-light metering. With incident metering, a diffu-

reflected light

luminance

incident light

the meter system

29

sion dome is placed in front of the sensor, the meter is placed at the subject, and the sensor is pointed back towards the camera position. This method measures the light falling upon, not reflecting off, the subject. The intensity of incident light is called "illuminance."

illuminance

TYPES OF METER SENSING

The photocell in the meter system is either a selenium cell (Se), cadmium sulfide (CdS), silicon (Si) photodiode (SPD), or gallium arsenide phosphide (GaAsP) photodiode (GPD). Manufacturers approach the possibilities of sensor placement differently, but all allow for the meter system to be one of four basic types: averaging, center-weighted, spot, or matrix.

Averaging meters are sensitive to the entire range covered by the lens.

Center-weighted meters give more attention to the center area of the viewfinder, but still incorporate readings from the edges.

Spot meters give total attention to the center area. Some systems allow you to use an *exposure memory lock* to lock in a spot reading. Some allow the possibility of averaging a few different "spot" readings, if so desired.

Matrix meters read light from myriad sensors and analyze the information through a microprocessor. These meters try to distinguish the subject from the background. A few matrix meters allow you to pre-program the microprocessor to weight the readings towards, say, greater depth-of-field (for landscapes), or faster shutter speed (for action photography).

Some cameras incorporate two or three of the above methods in their metering system.

METER DISPLAYS

In most cameras, the viewfinder displays the data gathered and information about exposure. The symbol, needle, dots, or numbers can be displayed by a physically moving mechanical pointer, LED (Light Emitting Diode) lights, or LCD (Liquid Crystal Display) digital displays.

The built-in meter system is integrated with the controls of the camera system; that is, it is directly coupled to the f-stop and shutter speed of the camera. Camera systems have different methods for letting the photographer know what exposure is needed. Your camera meter might use a match-needle arrangement (the f-stop ring controlling one, while the shutter speed ring controls the other). When the needle and what it has to match bisect, you have proper exposure.

You might have a meter system that requires you to line up a needle between a (+) and (-) sign, or a system where you see in the viewfinder a panel with a range of shutter speeds or f-stops. In this situation, when you adjust the f-stop or shutter speed control the meter changes a light or needle inside the viewfinder, designating a choice from the panel.

Manual Setting

A manual camera requires the physical setting of both the f-stop and shutterspeed scales.

DIAGRAM 11 METER DISPLAYS

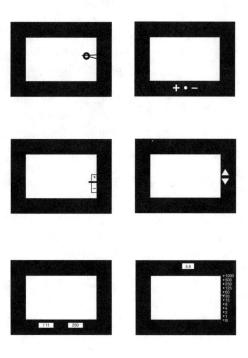

Automatic Setting

Aperture-priority

Shutter-speed priority

Program

A sophisticated automatic camera has any one of the following Automatic (A) adjustments, or modes: Aperture-priority (AP), Shutter-speed priority (SP), and Program (P). Your automatic camera might allow one, two, or all three of these possibilities, as well as a manual (M) override of the automatic selection.

With an "Aperture-priority" (AP) camera, you select the f-stop and the camera automatically selects and sets the shutter speed. Conversely, with a "Shutter-speed priority" (SP) camera, you choose a shutter speed and the camera automatically determines and sets the appropriate f-stop. There is no need to align anything. Many computerized cameras allow you to choose between these two priority systems. If the camera has a "Program" (P) mode, the camera automatically chooses both an f-stop and shutter speed combination in response to the intensity of the light striking the meter. You relinquish any choice in the creative decision making process to the engineer who designed the camera. At least if you choose an f-stop or shutter speed, you're making a decision that will affect the photograph. In "Program" mode you have no creative input!

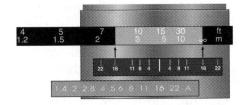

creative control via halves and doubles

4

Creative control becomes much simpler when you begin to understand that all camera manipulations and choices are related to each other in terms of halves and doubles. This concept applies equally to f-stops, shutter speeds, and film ISO.

THE STOP

The "stop" is a measure of change in exposure based on the amount of light reaching the film. It is referred to when f-stops and shutter speeds are changed, as well as when describing the difference in film speeds (see ISO, pg. 52). A one stop increase in exposure doubles the amount of light reaching the film. This increase can be achieved by setting the next larger aperture opening *or* by doubling the exposure time. A one stop decrease in exposure lets half the amount of light reach the film, either by setting the next smaller aperture opening *or* halving the exposure time.

This concept of "halves and doubles," along with understanding the light meter (discussed in Chapter 6) form the basic foundation for creative camera control.

Controlling Exposure: Shutter Speeds and f-Stops

Two controls determine film exposure: the shutter speed and the f-stop. These controls work together to regulate the amount of light that strikes the film. The f-stop controls the amount of light allowed through the aperture, and the shutter speed controls the length of time the light is allowed to strike the film. In other words, an exposure is an f-stop and shutter speed combination.

An exposure is an f-stop and shutter speed combination.

RECIPROCITY LAW

TxI=E

The Reciprocity Law states that Time (T) x Intensity (I) = Exposure (E). If the time is doubled and the intensity is halved (or the time is halved and the intensity doubled), the exposure (E) the result remains the same.

Equivalent Exposures

equivalent combinations

When your camera indicates an exposure combination, it is but one of many equivalent combinations, any of which would give proper exposure!

Example:

Your camera shows that a combination of f/5.6 at 1/60 would give a proper exposure. However, any equivalent combination would also give the proper exposure. If you changed the f-stop to f/8, the camera would have chosen 1/30 as the proper accompanying shutter speed. (See chart below.)

CHART 5 EQUIVALENT EXPOSURES

EQUIVALENT EXPOSURES								
f/22	f/16	f/11	f/8	f/5.6	f/4	f/2.8	f/2.0	f/1.4
4	8	15	30	60	125	250	500	1000

One stop less light (or half as much light on the f-stop scale) combined with one stop more light (or twice as much light on the shutter speed scale) give you an equivalent amount of light striking the film.

Example:

Your camera designates f/11 at 1/30 as the proper exposure. You decide you want a faster shutter speed, and set the camera to 1/250. The meter system adjusts and indicates that f/4 is required for an equivalent and proper exposure.

$$\frac{f/11}{30} = \frac{f/4}{250} + 3 \text{ stops increase (more light)}$$

$$\frac{-3 \text{ stops decrease (less light)}}{0 \text{ exposure change}}$$

A small f-stop opening for a long period of time is the same amount of light as a large f-stop opening for a short period of time. (For information about Reciprocity Failure, see *Final Tips on* page 91.)

Many novice photographers use the first f-stop/shutter speed combination their camera suggests. The resulting picture is properly exposed, but may not have the "look" the photographer intended. In many cases an equivalent f-stop and shutter speed combination could have accomplished the desired effect, because each combination produces a slightly different look. At times there are numerous possible combinations to choose from. Only you know what you are trying to accomplish in a photograph, so it is up to you to choose the proper equivalent. Don't leave it up to your camera to decide. A carefully chosen exposure combination can mean the difference between a creative photograph and a memory notation!

CREATIVE CONTROL— THE EXPOSURE COMBINATION

Example:

You took your last shot with the camera set at f/11. For the lighting conditions of your next shot, the camera's metering system shows you that the shutter speed should be 1/60 for an f/11 f-stop. You now have a proper exposure combination, but you may want to choose an equivalent combination for a different visual effect.

CHART 6
EQUIVALENT
EXPOSURE
COMBINATIONS

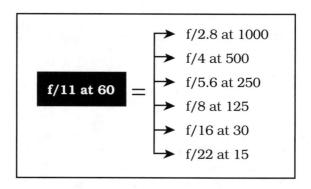

What if the photograph is dealing with motion or fast action? Would a faster shutter speed be desirable?

An aesthetic decision must be made to decide which f-stop/ shutter speed combination best suits the situation and your intention.

Remember, there is almost never only one choice or possibility. Take the time to consider other possibilities. You need to be conscious of what you are doing. If you want to control the medium and be creative with the camera, you must slow down, think, and choose your exposure combinations carefully. Consciously choosing the exposure combination that best suits the situation is the path towards creative camera control. Remember, each equivalent f-stop and shutter speed combination will give a properly

There is almost never only one choice or possibility. exposed photograph, but each will look different. It is possible that only one combination will produce the photograph that best fulfills your intention.

Simply put, you must choose one variable to control. If the variable you choose is the shutter speed, then you have to accept the corresponding f-stop for that specific lighting condition. Conversely, if you choose to set the f-stop, you must accept the shutter speed the meter system designates. Whenever you decide on one variable, you have no choice as to the other variable. If you don't like the corresponding variable shown by the meter system, alter your initial variable until the combination becomes acceptable. If you find no acceptable exposure combinations, don't take the picture.

For creative camera control. you consciously set either the f-stop or the shutter speed, depending on your purpose.

The Shutter Speed Choice

If the subject matter is moving, or the photograph is about motion, you must make a decision in terms of the shutter speed. A moving subject is visually important and usually primary to the success of a photograph. Once you decide on a specific shutter speed, you are locked into a specific f-stop for proper exposure. Under specific light conditions, only one f-stop is going to link with a specific shutter speed.

But how do you go about deciding what shutter speed to use? When choosing one shutter speed over another, there are three guidelines to keep in mind: speed, direction, and distance.

First, consider the speed of a moving object. How fast is the moving object going? You will need a faster shutter speed to stop the action of a running jackal than you will need for a walking dog. A horse at full gallop might be "stopped" with an exposure of 1/500 or 1/1000 of a second, while a tortoise at full gallop might 3 Guidelines of Relative Motion

Speed

37

take only a 1/4 to 1/8 second exposure.

To "freeze" the action of fast moving subjects, a fast shutter speed is necessary. For slower moving subjects, a slower shutter speed is possible.

2. Direction

Second, consider the direction in which the object is moving.

A train going across your field of vision needs an extremely fast shutter speed to stop the action—let's say 1/1000 shutter speed. If you stood on the track with the train coming directly at you, you might stop the action with only a 1/250 shutter speed.

An object moving toward or away from the camera needs a slower shutter speed to "freeze" the action than an object moving across the field of vision, which needs a faster shutter speed.

To understand this better, think about riding in a car. When you look straight ahead through the windshield, telephone poles, street lights, or cars in the opposite lane seem to approach you more slowly than when you turn your head and look out the side window. In this orientation, the same telephone poles, street lights, and cars appear to fly right by.

The direction the subject is moving in relationship to the camera is also an important factor.

3. Distance

The third factor to consider is the distance between you and the moving object.

For example, a 60 mph train is traveling across your field of vision, 20 feet away from you. You can stop the action with a very fast shutter speed. If the same train, moving at the same speed, were traveling in the same direction across your field of vision, but 1 mile away on a mountain pass, you could probably render it "stop-action" with a very slow shutter speed. At that distance, the train appears to creep along the mountain.

The farther a subject is from the camera, the slower the shutter speed necessary to "freeze" the action. CHART 7
SHUTTER
SPEED RATES

SLOW		MEDIUM			FAS	Т	RATE
1 2 4 8	15	30 60	125	250	500	1000	SHUTTER SPEED

So how do you know which shutter speed to use? There is no easy answer. You learn through experience and trial and error. You'll find you extrapolate when an object is moving on a diagonal towards you, or when a certain object is moving slower than the last time you photographed it. Speed, direction, and distance must all be kept in mind to make an informed choice, an intelligent guess.

Should you always stop the action of a moving object? Not necessarily. The slight blur of an object in a photo might actually be desirable. It gives the impression of activity, indicates that movement was taking place, or implies motion. If a man jumping over a log were stopped with a fast shutter speed, the photograph might look strange, with the man's body frozen in space. Although the perfectly sharp person might look interesting, that isn't how the eye normally perceives such movement. You would be extracting that person from reality. If the same situation were photographed at a slightly slower shutter speed, thus creating a blurred figure, the photograph would talk about a person in motion jumping from one side of the log to the other. It would imply movement in a two-dimensional still image. Consider your intention before choosing a shutter speed.

Movement offers many creative possibilities. You might want to transform what you see using motion.

You could set your camera on a tripod and point the lens down at a stream with swiftly running water breaking around some rocks. Take one shot with a fast shutter speed, and you'll get stop action of running water with splash droplets suspended and floating in mid-air. From the same location, on the next frame, choose a very slow shutter speed. The result might resemble an aerial photograph of low lying clouds with mountain peaks breaking through the clouds. The rocks might become the tops of mountains and the blurred rushing water might be transformed into lush white clouds.

panning

Panning is a technique whereby the moving object is relatively sharp and the background is blurred in the photograph. This is accomplished by moving the camera during the exposure, so the subject remains in the same position in the viewfinder. It is important to begin the pan before releasing the shutter and to continue the steady movement until well after the shutter has closed.

The Three Factors Controlling the Depth-of-Field

1. F-stop

You choose the f-stop when you want a particular depth-of-field. The depth-of-field is a variable zone of acceptably sharp focus in front of and behind the object the lens is focused on. The choice of f-stop determines how shallow or deep this zone of focus will be. After you select the f-stop, the meter system will determine the shutter speed necessary for proper exposure.

If you begin to think and conceive of your photograph in the way that the camera lens records it, you will become aware of your ability to control the range of focus around your subject!

The smaller the f-stop opening, the greater the range of sharp focus. The larger the f-stop opening, the narrower or more shallow the range of sharp focus.

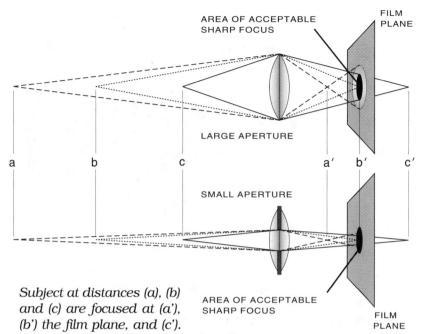

Discs of light, called circles of confusion, are projected on the film plane from (a), (b), and (c). With the large aperture, (a') falls outside the area of "acceptable" sharp focus and will be considered out-of-focus; (b') is pin-point sharp; (c') falls within the area of acceptable sharp focus. The small aperture creates smaller discs that allow (a'), (b'), and (c') to fall within the area of acceptable sharp focus.

DIAGRAM 12 CIRCLES OF CONFUSION

Many lenses (particularly fixed focal length normal and wide angle lenses) have a depth-offield scale. However, many auto-focus and most zoom lenses do not have a usable or functional depth-of-field scale.

The depth-of-field scale is located on the lens barrel, usually between the f-stop scale and the focusing ring scale. This immovable scale has the focusing index mark located at its center. Symmetrically placed on either side of the focusing index mark are lines marked with

numbers referring to f-stops. Manufacturers, give varying attention to the readability of the depth-of-field scale. Some include all the pos-

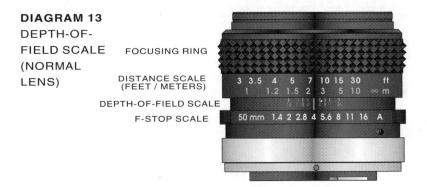

DIAGRAM 14 DEPTH-OF-FIELD SCALE (ZOOM LENS) sible f-stop numbers, and others just a few. Still others, like Nikon, use color-coded lines, printing the f-stop on the f-stop ring in the same color as the number on the depth-of-field scale. Some zoom lenses do have a depth-of-field scale, generally a set of converging curved lines.

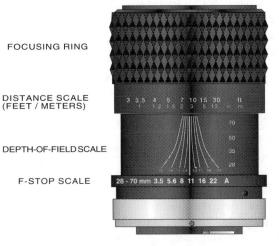

When you focus lens a with a depth-offield scale, the subject's distance is indicated above the focusing index mark on the distance, foot/meter (ft/m) scale. When properly focused, the subject will be sharp as long as the camera does not

move during the

exposure. In addition, an area in front of and behind the

subject will also be sharp. This depth-of-field is generally divided into a 1/3 to 2/3 ratio around the subject; that is, 1/3 of the range of sharp focus is in front of the subject, and 2/3 of the range of sharp focus is behind the subject. The

DIAGRAM 15 FACTORS AFFECTING DEPTH-OF-FIELD

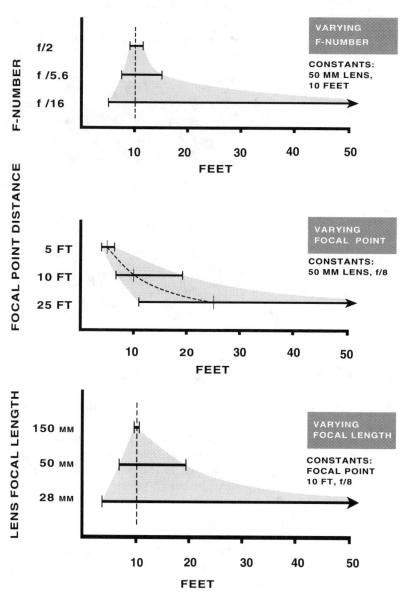

For any given focal length, you control the range of sharp focus with the f-stop.

range of that space can be increased by choosing a small f-stop opening, or decreased with a large f-stop opening.

The closer the subject is to the camera, or the longer the telephoto lens, the more even the ratio becomes (1/2 in front to 1/2 behind).

The range of sharp focus is the distance shown between the two markings on the depth-of-field scale for the f-stop selected.

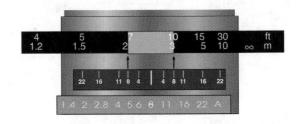

DIAGRAM 16 DEPTH-OF-FIELD: F/8 AND F/22

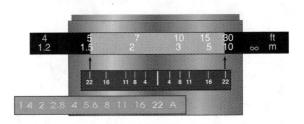

2. Focal length:

The shorter the focal length of a lens, the greater the depth-of-field at any chosen f-stop.

3.
Camera
to subject
distance:

The depth-of-field increases as the camera -to-subject distance increases.

Note: If you do not have a depth-of-field scale on your lens remember that the smaller the f-stop opening, the greater the depth-of-field and the more you will have in sharp focus. The larger the f-stop opening, the shallower the depth-of-field will be.

Ways to use the Depth-of-Field Scale

Probably half of all photographs taken by amateurs are taken with the lens focused at

infinity. Generally the intention in these cases is to get as much in focus as possible.

Hyperfocal focusing is an attempt to obtain the maximum depth-of-field for any selected f-stop. If the infinity (∞) symbol on the focusing ring is set over the mark on the depth-of-field scale that corresponds to the selected f-stop to be used, then the photograph will have the maximum depth-of-field for that f-stop. The greatest distance in focus will always be infinity. The nearest point of sharp focus will be approximately half the distance from that indicated above the focusing index mark. The distance directly above the focusing index mark is called the "hyperfocal distance."

Hyperfocal Focusing

Example:

Focused at ∞ , the depth-of-field is 15 ft.- ∞ using f/16. With hyperfocal focusing, by swinging the ∞ mark over the selected f-stop on the depth-of-field scale the range is $8ft.-\infty$, an increase in the amount of foreground in focus.

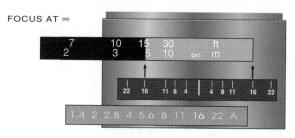

DIAGRAM 17 HYPERFOCAL FOCUSING (AT F/16)

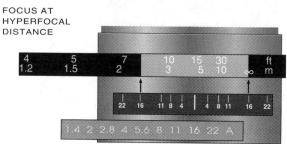

Shallow Depthof-Field Focus

When you focus or look through a lens, you are always looking through the largest possible f-stop opening for that lens, no matter what f-stop is set. This shallow depth-of-field enables you to focus on your subject; you can read off the lens the subject's distance from the camera. The only area that looks sharp is located at the distance shown above the focusing index mark. At the moment of exposure, however, the lens closes down to the selected f-stop, thereby creating the proper depth-of-field for that f-stop (as indicated on the depth-of-field scale). This occurs simultaneously with the mirror flipping up (on SLRs) and the shutter opening. When the exposure is completed, the mirror flips back down and the lens returns to the shallow depth-of-field of its largest f-stop opening.

Depth-of-Field Preview

If you want to preview the depth-of-field before the exposure is taken, you may do so if your camera has a depth-of-field preview switch or a manual "M" switch. In all honesty, it is a pretty useless control. To preview the depth-of-field at a small f-stop opening, the lens aperture closes down and makes the viewfinder so dark that it is difficult to discern what is indeed sharp. If you have a depth-of-field scale, you can be far more accurate in predicting what your photograph will accomplish. You can refer to it to see what distances will be acceptably sharp in the photograph.

Advanced depth-of-field control

Zone focusing

Zone focusing is a method for predetermining a range of sharp focus for the photograph using the depth-of-field scale.

Example:

Walking along a country road, you come across a beautiful old apple tree in the middle of a field. You look at the scene and decide you want the focus to extend from the hand-built stone wall in the foreground to the white clapboard farm house way in the distance. (Obviously the apple tree will be sharp if the planes in front and behind it are.)

- 1) To zone focus, you focus first on the nearest object you want sharp, the stone wall, and look at the distance scale on the lens to determine that it is 8 feet away.
- **2)** You focus next on the farthest object you want sharp, the farmhouse, and look again at the focusing mark to see that the distance is infinity ().
- **3)** Moving the focusing ring, you place these two symbols so they lie equidistant from the focusing index mark. The focusing mark acts as the fulcrum between these two distances. The symbols 8 and now line up over (or possibly inbetween) the same f-stop markings on either side of the focusing index mark on the depth-of-field scale.

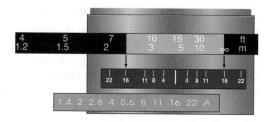

DIAGRAM 18 ZONE FOCUSING 8 FEET -

The marker shows that what is going to be sharp is 15 feet away. But, what actually will be in focus is the range that exists between the f-stop markings on the depth-of-field scale for that selected f-stop.

4) You leave the lens focused as is and *manually set* the camera to the indicated f-stop, f/16. Next you determine the shutter speed exposure that corresponds to f/16 in this lighting condi-

tion. You have now consciously decided the proper exposure and range of focus you want for your photograph.

Some autofocus cameras can accomplish this zone focus via a specific "depth-of-field" mode setting. After activating this mode, you focus on the closest point you want in focus, then the farthest point. The camera automatically remembers these distances and sets the necessary f-stop needed. You then reframe the photograph in the viewfinder. The range of sharp focus has been calibrated, the appropriate f-stop has been set, and the needed shutter-speed has been set. If the camera can't set the parameters you select, it signals you.

Zone Focusing and Creative Freedom

Almost all amateur photographs are taken with the subject "dead center" in the frame, exactly where the focusing ring is located. More often than not this creates a very static composition. Don't let the focusing ring impose itself on your compositions. Zone focusing can give you the freedom for more creative compositions and a fresh vision. Even if you choose not to zone focus, you can improve your composition by reminding yourself to reframe the scene after focusing. If you focus on a centered object and then reframe it on the left or right side of the frame it will still be in focus and the resulting photograph may have a more dynamic composition. Remember, the camera is still the same distance from the subject. Even with an autofocus camera, you can lock the focus on the subject and then re-compose the picture.

Zone focusing is also extremely helpful when you want to shoot swiftly and spontaneously. For example, in "street" or candid photography, it is sometimes difficult to focus on a moving object such as an interesting looking person who is walking towards you. Often you do not have enough time to get them in focus before they pass by. In situations like that, why not set a zone of sharp focus?

Example:

Stand on the sidewalk and focus first on a parking meter 12 feet away and then on one 25 feet away. You want to set that space in sharp focus so that anyone walking through that space would be in focus. Set those two distances equidistant on the depth-of-field scale and determine the f-stop needed. Now, find out what shutter speed corresponds to that f-stop.

If the chosen f-stop gives you an acceptable shutter speed, leave the focusing ring alone. Now anyone who walks into that predetermined range will be in focus. All you need to do is wait for the right person, situation, or event to occur in that space. You don't have to be concerned with focusing directly on any single moving object. You have now set the stage to give yourself creative freedom for seeing and shooting spontaneously.

If the shutter speed is too slow for your wishes, there are three choices. You can use a faster ISO film, decrease the depth-of-field (larger f-stop opening uses a faster shutter speed), or stand farther away (which will allow you to use a larger f-stop opening and maintain the same depth-of-field). Remember, the closer you are to the subject, the shallower the depth-of-field.

The central location of all focusing systems often results in "centered" and static composition. The optimum camera design for creative results would place the focusing ring at the bottom corner of the viewing screen. Focusing would then require the photographer to shift the camera upward. Once the focus was set, the photographer would re-compose. Camera designs being what they are, the zone focusing method is the next best guarantee that

you will re-compose each picture in the viewfinder after focusing for the required depth-of-field.

film

Understanding both technical and conceptual aspects of film can help you obtain creative control.

FILM STRUCTURE

Basically, film is made by coating a lightsensitive suspension on a cellulose ester support base. The light-sensitive suspension, the emulsion, is made of silver halides and gelatin. Silver halide (silver salt) crystals are light sensitive. Color films are similar to black and white films except that they have dyes coupled with the layers of silver halides. In different emulsions, the silver halides vary in size and arrangement. Some manufacturers produce particularly unique films. Kodak's T-grain film is composed of flat-tabular crystals, whose multi-faceted surface picks up more light than conventional silver salts. Konica's "monodisperse crystals" and Agfa's "twin-grained" flat and compact crystals are examples of other unique technologies. Each attempts to optimize speed and grain characteristics.

The rear surface of film is coated with an antihalation dye that absorbs light. The dye coating prevents light from penetrating through the base, which would scatter or reflect off the pressure plate and back through the film.

DIAGRAM 19 FILM

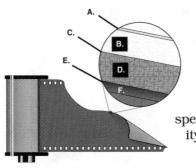

- A. ANTI ABRASION SUPERCOAT
- B. EMULSION
- C., E. SUBBING (ADHESIVE)
- D. FILM BASE
- F. ANTIHALATION BACKING

ISO / ASA / DIN

A standard terminology called ISO (International Organization of Standards) numbers or film speeds categorizes the light sensitivity of all film emulsions. At one time there were two systems in use: the ASA (American Standards

Association) numbers, which related to each other arithmetically; and the DIN (Deutsche Industrie Norm) numbers, relating logarithmically. ASA and DIN have been phased out, and the ISO system is now universally used. The American Standards Association has now become ANSI, the American Standards Institute. One might also find terminology related to the non-standardized EI (Exposure Index) when discussing film. The ISO number is the former ASA number combined with the old DIN num-

CHART 8
ISO/ASA/DIN
EQUIVALENTS
(See Appendix 1,
page 97 for a
complete table)

ISO	ASA	DIN
25 / 15°	25	15
32 / 16°	32	16
50 / 18°	50	18
64 / 19°	64	19
100 / 21°	100	21
125 / 22°	125	22
160 / 23°	160	23
200 / 24°	200	24
400 / 27°	400	27
1000 / 31°	1000	31
1600 / 33°	1600	33
3200 / 36°	3200	36

ber (a degree mark designates a logarithmic number).

It is universally acknowledged that the ASA and ISO numbers are interchangeable. The camera's metering system must be set to the light sensitivity of the film in the camera. This can be done either manually or (as previously discussed) automatically, through DX coding.

Each ISO/ASA film speed number is 1/3 stop faster than the preceding one.

(Note: Only the ASA part of the ISO number will be used when discussing film speed. The standard ISO/ASA numbers are shown here.)

6	8	10
12	16	20
25	32	40
50	64	80
100	125	160
200	250	320
400	500	650
900	1000	1250
1600	2000	2500
3200	4000	5000

CHART 9 ISO / ASA FILM SPEEDS

HIGH VERSUS LOW ISO/ASA

As a rule, the higher the ISO number, the less light the film needs for a proper exposure. The trade-off is that it produces a "grainier" looking photograph. The larger you blow up the image, the more obvious the grain will be. For some, a grainy photograph is an aesthetic preference. The choice of film helps determine that final "look."

CHART 10 ISO CHARACTER-ISTICS

LARGER	LESS	LESS	HIGHER
GRAIN	LIGHT NEEDED	CONTRAST	ISO NUMBER
SMALLER	MORE	MORE	LOWER
GRAIN	LIGHT NEEDED	CONTRAST	ISO NUMBER

Beware: Some photographers fall into the trap of always choosing a fast film (high ISO number). But there are many everyday situations where a 400 ISO film is too sensitive. For

example, you should think twice about taking 400 speed film to a sunny beach. Your camera's smallest f-stop and fastest shutter speed might not be able to close out enough light. In this case, the film is too sensitive, too fast. Shoot with less sensitive, "slower "(lower ISO) films in bright situations, or use a neutral density (ND) filter to reduce the light intensity (see pg. 78).

It's a good idea to have a range of different speed films on hand at all times. If you refrigerate your film, you can easily extend the expiration date. If you freeze the film, you can slow the aging process even further. Film that has been refrigerated or frozen must be brought to room temperature before opening the plastic cap on the film container, because rapid temperature changes can cause condensation on the film, ruining it. A minimum warm-up time of one hour for refrigerated film and four hours for frozen film is suggested.

FILM SPEEDS: HALVES AND DOUBLES

Remember, all of photography is based on halves and doubles. That goes for the ASA rating of film, too. A film that is rated 400 is twice as sensitive, or twice as fast, as a film rated 200, and therefore needs half as much light or one stop less light to be correctly exposed. Likewise, a film rated at 50 is half as sensitive, with half the speed of a film rated at 100, and needs twice as much light or one stop more light to be correctly exposed.

Example:

Two photographers with identical camera systems photograph the same scene at the same time side by side. Lynn has 100 speed film in her camera. Alex has 400 speed film in his camera. Both make proper exposures using an f-stop of f/11. The difference is in the f-stop/shutter

speed combination for the two cameras. With a 100 speed film in her camera, Lynn determines that at f/11 the necessary shutter speed is 1/60. With 400 speed film, Alex determines the necessary shutter speed to be 1/250 at f/11.

This is a two-stop difference. From 100 ISO to 200 ISO is one stop, and from 200 to 400 is another stop. So Alex needs exactly two stops less light for proper exposure. The camera's metering system automatically gives the necessary combination, and Alex uses a faster shutter speed.

In the above example, if the shutter speed had been the constant, there would have been a two-stop difference in f-stops needed.

All other things being equal, you need more light striking the film with the lower ISO film speed. A low ISO film is "slower" film than a high, "faster" film. The difference between 50 ISO film and 400 ISO film is 3 stops of light, just as between 400 ISO film and 3200 ISO film.

PURPOSEFUL "OVER" AND "UNDER" EXPOSURE

DX Override

Almost all films are now DX coded. Most cameras that automatically read this DX code allow the photographer to manually override the DX setting and create a purposeful over or under exposure of the film.

Exposure Compensation Dial

Most other cameras have an exposure compensation dial. This dial allows you to adjust the exposure from +2 stops overexposure to -2 stops underexposure in half-stop increments. On some cameras +1 is designated x2 (double the exposure, or one stop more light); +2 is designated as x4 (quadruple the

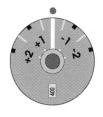

DIAGRAM 20 EXPOSURE COMPENSATION DIAL

exposure, or two stops more light), -1 as x1/2 (one-half the exposure, or one stop less light); and -2 is designated as x1/4 (one-quarter the exposure, or two stops less light).

FILM CHARACTERISTICS

Technically, films can be categorized according to the following characteristics: Color Saturation, Color Balance, Contrast, Grain, Sharpness, Resolution, and Latitude.

Color Saturation is the density of a color.

Color Balance is the relationship of exposed film to the original scene, or its accuracy, usually based on skin tones in midday sunlight.

Contrast is the range of densities the film is able to record.

Grain is the size, shape, and distance between developed silver crystals. An important aesthetic factor in choosing a film; grain affects one's impression of sharpness and resolution as well as maximum enlargement size.

Sharpness is the ability of the film to produce a distinct edge between two tones.

Resolution is the ability of a film to reproduce fine detail.

Latitude is the ability of the film to give acceptable results with over and under exposure. Black and white films have a greater latitude than color films, and negative producing films have a greater latitude than slide films.

Many film manufacturers, like Kodak, Ilford, Agfa, Konica, and Fuji, make excellent and highly regarded films. Film choice is a matter of personal preference.

light concepts and creative control

A basic understanding of light concepts can help you match light to your subject and purpose, giving you greater creative control.

USING DIRECTIONAL LIGHT

As a photographer, it is important for you to be sensitive to the direction and quality of light falling upon the subject. If you carefully consider the effect that different directions of light might have on your subject, then you can match the lighting to your purpose and increase your chances of producing a successful photograph. In photography, there are four basic types of directional light: front light, side light, back light, and revealing light. In order to determine the type of light falling upon your subject, look at the subject's shadow. (Don't look at your own shadow, because you may be in a different type of light than your subject.) Look to the subject's shadow to determine the light. You will know that you are dealing with

•

Look to the subject's shadow to determine the light.

directional light when the shadow of the subject is equal to or greater than the subject itself. When the shadow is shorter than the subject, it is considered "top light," and the creative possibilities of using the directional light are diminished.

Front Light

Front light comes from behind the photographer's shoulder, falls directly upon the subject, and casts a shadow behind the subject. The effect of these shadows is not important since they are mostly blocked by the subject. Front or direct light lowers the contrast range of the scene, fills in the subject's surface shadows, and reduces the perception of texture and volume. With the sense of volume diminished, you have flat features. (Direct flash also produces this type of light. To avoid this quality of light, photographers often bounce-flash, or use a flash held off-camera.)

Example:

Imagine in your mind's eye a front-lit redwood forest. The light fills in the bark, eliminating the sense of texture and volume. Massive shadows from the trees are cast backwards into the forest. Just a few yards into the scene, the photographed forest would seem very dense and uninviting, because of the darkness.

Side Light

In side light, the subject's shadow is cast off to the side. One side of the subject is lit, while the other side is in shadow. With side light there is a strong sense of volume and texture. Side light is subconsciously a very powerful light. There is a distinct vertical line that separates the light side from the dark side. There is a dichotomy between the light and dark. A tension exists in these tonal opposites, in this separation between light and dark. Metaphors such as positive/negative, black/white, yin/

yang, and good/bad will play a part in the interpretation of the viewer. The vertical line that separates the light from the dark is itself important. Throughout all of art history, vertical lines have stood for strength and power, for reaching to the heavens. In contrast, horizontal lines have always stood for rest, calm, tranquility, and peace.

See for yourself. Bend your lower arm from the elbow and hold it vertically in front of you. Now bend it so it is horizontal. The vertical and horizontal positions of the arm connote very different qualities. Is an arm with a clenched fist more powerful looking when it is held vertically or horizontally?

Imagine again in your mind's eye that same redwood forest, this time side-lit. The tree shadows are cast off to the side. Half the trees' bark is lit, showing detail and volume, while the other half remains in shadow, a reinforcement of texture and form. The vertical line that separates the light side from the shadow side of the trees echoes the trees' verticality.

Back Light

Back light comes from behind the subject, casting the shadow to the front. You have back light when the subject stands in front of a bright window, or with an open sky. Back light creates strong contrast between the light source and the shadow cast in the foreground. The foreground subject usually has very little detail. Back light is a very alluring light that draws you in. It has almost a religious connotation because of the "halo" effect it gives to some subjects. Hollywood actresses are often photographed in back light to create sensual appeal.

Imagine the redwood forest in back light, the source of light coming from deep within the forest. The shadows are now cast towards you.

 \blacksquare

You can manipulate the emotions of the viewer ever so subtly by controlling the way light strikes your subject. The edges of the trees are shimmering: the dark side of the bark shows little texture. The forest has almost a spiritual presence, and you might feel drawn to enter the scene. Without correction, the trees would be a pitch black silhouette, and not very inviting. But you can make a conscious creative decision to control it.

Revealing Light

Revealing light is the light that exists on an overcast day, or the light cast by fluorescent lights. It is a broad, diffused light. In revealing light, the shadows are evenly dispersed around the subject. There is no apparent direction or distinguishable source of light. The subject is "revealed" in all its form, with a softened sense of texture, volume, and detail. This can be a very desirable type of light, especially when using color film. Don't be just a "sunny day" photographer.

The redwood forest under revealing light would be approachable. The surface shadows would be softened, yet there would still be texture and volume.

The subject matter, redwood trees, has been the same in all these examples, but you can sense how very different the side-lit redwood trees were from the back-lit redwoods. The direction of light affects the impact of the photograph and our interpretation. The subject was the same "redwood forest." It was the light that made the difference.

Matching the light to the purpose is important for success. If an architect wants a photograph that shows a building's form and volume, a strong side light would be the appropriate choice. The architect would want to avoid showing the building in front light.

If you wanted to show the beauty of ripples on a sandy beach or the undulating patterns of

Color film often gives its best results under revealing light conditions. freshly fallen, wind-blown snow, then you would seek back light, in order to capture texture. Front light would be avoided here, too.

How we see and choose the light to photograph our subject can make the difference between a photograph and a snapshot. You must be sensitive to how light strikes that subject at that moment.

METER CONTROL

If you understand how your exposure meter works, then you can master all lighting situations. Whether the meter is built in or hand held, if you understand how it works, you will be able to use your camera in difficult lighting situations, conditions where your meter is apt to choose an inappropriate exposure. With knowledge you will be able to overcome and correct for the proper exposure.

18% Reflectance

All the various meter systems average the light entering its sensor to determine the f-stop and shutter speed combination. In a range from pitch black to absolute white, the average tone reproduced in a print represents a middle gray. This mid-gray has been determined to be 18% light reflectance. No matter what type of metering system your camera employs, all meters average light to the mid-point of the photographic gray scale, which is 18% reflectance.

(You might expect that the mid-point of the gray scale would be 50% reflectance, but 50% reflectance is a very light gray.)

Zone System Terminology

At this point we need to extend our vocabulary to more easily understand how to further control the camera. The language we use is called "zone system" terminology, and it

V

Photography is not the capturing of subject matter on film, but the etching of light in silver. It is the light that is your medium. Light is the mordant, silver the ground.

mid-gray = 18% light reflectance allows us to describe subjective photographic information.

The "zone system" approach to photography most commonly used today is Minor White's interpretation of Ansel Adams' zone system. While we will only be using the language of the zone system, many advanced photographers use the "zone system of exposure and development" to control and master other technical aspects of the medium. Critics of the system feel it is too exact and laborious. But, the language of the zone system is remarkably clear and understandable, and will allow us to put to creative use all we know. This is important for both color and black and white photography.

DIAGRAM 21 CONTINUOUS TONE GRAY SCALE

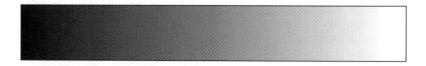

DIAGRAM 22 ZONE SYSTEM SCALE Now, let's divide that scale into ten different sections, or zones. Each zone has a darker and a lighter side to it, since it is a continuous tone scale. The mid-point of each zone is what is represented in the Zone Scale below:

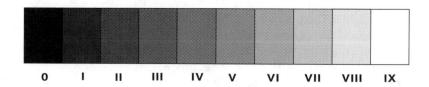

Let's discuss photography in terms of this pitch black to absolute white continuous tone scale. We use Roman numerals to "describe" zones, and any object in a photograph can be ascribed to these zones.

ZONE	DESCRIPTIVE PROPERTIES (PRINT)
0	Absolute black. The darkest the photographic paper can get.
	Black. Hint of tone, but no texture.
	Darkest gray (e.g., deep shadows, just perceptible texture in the black).
	Darker gray (e.g., full shadow detail and texture, dark clothing).
IV	Dark gray (e.g., average dark green foliage, very dark skin in indirect light, or white skin in deep shadow).
V	18% reflectance. Middle gray. (e.g., brown or dark skin, denim jeans).
VI	Light gray (e.g., average white skin, snow in shade).
VII	Lighter gray (e.g., blue sky, side-lit snow or sand).
VIII	Lightestgray(e.g., bright cement, white paint, bright hazy sky, bright snow).
IX	Paper white (e.g., spectacular highlights, no texture).

CHART 11
DESCRIPTION
OF ZONE
VALUES

USING THE ZONE SYSTEM

The zone system is an effective means of gaining creative control. But in order to fully control the camera you must be aware of two concepts which are the foundation for understanding creative control.

First, the relationship between stops is either halves or doubles, and, second, the meter averages light to the midpoint of the gray scale, Zone V, 18% reflectance.

Two concepts necessary for understanding creative control.

CHART 12 INTER-RELATIONSHIP OF ZONES AND STOPS

One zone = one stop

Each zone is one stop away from the next one in exposure; each zone is twice as much light or half as much light as the zone next to it. Once you understand the interrelationship

0	5 stops less exposure than Zone V		
I	4 stops less exposure than Zone V		
II	3 stops less exposure than Zone V		
III	2 stops less exposure than Zone V		
IV	1 stop less exposure than Zone V		
	1 diop 1000 expectate than 2011c v		
ZONE V	18% REFLECTANCE. MIDDLE GRAY.	ZONE	١
		ZONE	1
ZONE V	18% REFLECTANCE. MIDDLE GRAY.	ZONE +	1
ZONE V	18% REFLECTANCE. MIDDLE GRAY. 1 stop more exposure than Zone V	ZONE	1
ZONE V VI VII	18% REFLECTANCE. MIDDLE GRAY. 1 stop more exposure than Zone V 2 stops more exposure than Zone V	ZONE	1

*Zone X and higher are possible to record on film, but they are not visible in a print.

between stops and zones, control is yours. A one-stop change in exposure is a change of one zone. Two stops=two zones.

Your camera's meter system expects you to include in the photograph a range of dark and light subjects on either side of this "average" mid-gray. It will take the light from the dark areas and the light from the bright areas, blend them together, and give an f-stop/shutter speed combination that will match Zone V. When the shot is taken and the lens sharpens the details, those objects that are darker than Zone V will record darker and those objects that are lighter than Zone V will record lighter, based upon that midpoint. The meter is calibrated

only to give an exposure to match a Zone V.

The meter is calibrated to give an exposure to match Zone V.

Obviously there will be problems when the scene you wish to photograph doesn't conform to the "average" situation. The meter cannot sense when the situation isn't average. If you want to photograph a solid white wall, for example, you have to consider your purpose and make adjustments accordingly. Remember, the meter is calibrated and designed to take whatever light is coming into its sensor and average the light that enters to a mid-gray, 18% reflectance.

The following examples describe how to make "zone placement" corrections.

On the first frame of a roll of film, shoot a closeup detail of a solid black wall. Fill the entire frame with the black wall. Take the shot with any f-stop and shutter speed combination the camera suggests. (You're not concerned with choice of shutter speed or the f-stop. The subject is not moving and there is no depth-of field to a flat surface.)

1.

The camera's meter system expects to average a range of tones. It has no mechanism for calculating a monotone situation. It takes the light reflected off the black wall and averages it to the midpoint Zone V, to determine an exposure. The photograph will match a perfect Zone V tone; i.e., it will be gray and not black.

This example shows that you can receive an improper exposure for a subject from an accurate, functioning meter. The wall in the photograph was reproduced as a Zone V middle-gray, because the meter did its job well! Clearly, there are situations that require the photographer's intervention.

4 2.

Based on our knowledge of how meters work, we need to make a correction. If we want the close-up photo of the black wall to be a barely perceptible textured black, as it really is, then we want to reproduce it in Zone II. To do that, we need to close down from what the camera believes it should be—letting in 3 stops less light.

Corrections can be made on either the f-stop or the shutter speed scale (or on a combination

of f-stop and shutter speed). We must have 3 stops less light striking the film, in order to render the wall in Zone II.

Zone V to Zone II = 3 Zones Less Light 3 Stops Less Light = 3 Zones Less Light

3. • On frame #3 of the same role of film, you want a photograph of a white wall. Meter the wall and use the combination it gives. Again, using the combination the meter gives you, you will end up with another middle-gray, Zone V photograph. In fact, you won't be able to tell the difference between frame #1 and frame #3. Both the photograph of the black wall and the photograph of the white wall will be Zone V mid-gray walls. Again, your meter has performed correctly. It gave everything 18% reflectance.

In order to make the white wall in the photograph white, with a slight hint of texture, you would want the white wall in the photograph reproduced in Zone VIII. Therefore, you must override the meter by letting in 3 stops more light then the meter system says it needs! The correction of 3 stops could be made on either the f-stop or the shutter speed, or on a combination of f-stop and shutter-speed modes.

Overriding the Meter

The meter system must be corrected by overriding the designated exposure. The camera must be set on manual and not any of the Automatic (A) modes, which include: Aperture-priority (AP), Shutter-speed priority (SP), Automatic (A), or Program (P). Remember, these are all types of "automatic" settings for averaging to Zone V. If your camera is set to any of these modes when you try to make a correction by opening or closing the f-stops, the camera will automatically counter that adjustment on the shutter speed scale. Likewise, if you try to correct with the shutter speeds, the camera will

counter that move by readjusting the f-stops back to an exposure equivalent to the original reading. The camera will automatically return the exposure to Zone V, which is an incorrect exposure for that subject.

With "automatic" cameras, you must manually set the f-stop and shutter-speed the camera suggested in its automatic mode. On a manual camera, find the suggested setting. Next, make the correction. The meter system will blink, flash, or not align, somehow trying to convince you not to take the shot. It wants to get back to neutral, Zone V, but you know you need to override what it is telling you in order to make a proper exposure! You can't trust the meter to give you a proper exposure. You can only trust the meter to give you Zone V.

Have you ever photographed someone indoors in front of a window? Did you end up with a silhouette? That's because you made an exposure at the indicated meter reading, rather than thinking through the problem at hand.

- ▶ Here is what happened: Light entered the meter from the window behind the person. There was more light coming into the meter from the window than there was reflecting off the person within the room. When the meter averaged the scene to Zone V, it made the window, the dominant source of light, reproduce at Zone V or VI. The person who should have been in Zone VI (if white skinned), reproduced in Zone II or III, looking like a silhouette.
- ▶ Here is how to control the situation: You know the white skin should be in Zone VI. Get close to the person and take a meter reading off her face. Don't allow the meter to point into the window light. The meter will give you an f-stop and shutter-speed combination that will make the skin of the face Zone V. (The meter always averages the light to Zone V.) Since you know the skin should be Zone VI, you open up, or let in, one

stop more light than the meter has determined. The skin will now be in Zone VI. If you choose to have the skin reproduce darker, you can take the reading of the skin and make no correction, leaving the skin in Zone V. Now, go back to your original position and reframe the composition with the window. Once one tone is set, all other tonalities are correct in relationship to it. If the skin is correct, everything else has to be right, too.

Knowing how the meter works allows you to figure out what the meter is doing and correct forunusual situations. You'll no longer get trouble-some results with no clue as to why your photographs have poor exposure. Single-toned subjects, like snowscapes, or subjects heavily back-lighted, like an interior shot of someone at a bright window, will no longer be a cause for concern. For unusual conditions this "zone placement" metering correction system will be invaluable.

zone placement

Review:

Go up to the subject and meter a single tone. The camera will determine an exposure, placing that tone in Zone V. Correct that single tone as necessary, by overriding the camera. Go back to your original location to compose and take the picture.

You may find that it is time consuming and intrusive to take a close-up meter reading on a single tone, correct that tone by placing it in the proper zone, and then walk back to compose the picture. In most general lighting situations you may wish to utilize light direction correction.

LIGHT DIRECTION CORRECTION

Light direction correction is a useful method when you want to meter from the camera position. No corrections are necessary and you will have excellent results using the exposure indicated by your

meter, except in cases of back light.

Photographers who do their own printing find that the following corrections give them slightly better negatives to print from, by rendering a little more detail in the shadows. Others feel that the corrections make negligible difference and therefore are not worth the time or effort. But all agree that the corrections are necessary for back light.

The corrections range from no increase for front light, to a 1/2 stop increase in exposure for side light, usually 1 to 2 stops increase for back light (1 1/2 stops is a popular choice to correct underexposure in back light), and up to a 1 stop increase for revealing light.

For slide film (called "positive" film, "reversal" film, or "chromes"), no corrections should be made except for back light, with only an increase of 1/2 to 1 stop of exposure.

All these corrections increase exposure, letting in more light. This is accomplished by using a slower shutter speed or by opening to a larger f-stop aperture (a smaller f-number). Correcting with the f-stop affects the depth-of-field, and correcting with the shutter speed affects motion or movement. Corrections can also be made using the exposure compensation dial.

In front light, a general overall meter reading is accurate, no matter what the intensity of the light. The contrast range of the scene falls within the "zones" capable of being recorded on film.

Front Light (0)

When the subject is in side light, most photographers go with the meter reading. But some like to increase the exposure by $\pm 1/2$ stop, in order to slightly increase the shadow detail. On most cameras this is accomplished on the f-stop scale, because one can't set shutter speeds between stops. F-stops can be set anywhere between the stops. Some digital cameras have the ability to set shutter speeds between stops.

Side Light (+1/2 stop optional)

Back Light (+1 1/2 stops necessary)

Take the meter reading and open up with 1 to 2 stops more light. Some cameras have a back-light switch that automatically increases the exposure 1 1/2 stops.

Recall the back-lit redwood tree example on page 59. Without a correction, the trees would be dark, without texture, uninviting. You have to decide how much of a correction to make, how much of a silhouette you want. Opening up 1 1/2 to 2 stops might be too much of a correction, making the background overly bright and washed out, though it allows detail in the subject. You might want to compromise and increase the exposure a little, maybe just a stop. This is your creative decision.

Revealing Light (+1 stop optional)

This is a broad source of light, without harsh shadows, which easily falls within the contrast range of films. Most photographers don't bother making a correction here. Those that do, open up no more than +1 stop increase in exposure.

You now know two ways to approach the problem of photographing someone standing at a bright window: zone placement correction and light direction correction. Use one method or the other. Do not combine the two systems.

Review:

Zone Placement correction example:

Walk up to the person, take a meter reading off her face, and place the Zone V reading in the appropriate zone for her skin. Then return to your position to compose and take the shot.

2. Light Direction correction example:

Stay at the camera position you have chosen for the photograph and take the meter reading as you normally would. Now, open an additional 1 1/2 stops to the suggested exposure in order to prevent the person from becoming a silhouette.

"Sync Speed"

When using flash, a focal plane shutter is limited to the specific maximum shutter speed for that camera, usually 1/60 or 1/125 (a few are as fast as 1/250). This maximum speed is called the flash synchronization or "sync speed" of the camera. Shutter speeds that are slower than the "sync speed" can always be used. But using a "sync speed" faster than designated will produce photographs with part of the frame pitch black and the remainder properly exposed. This is because, at speeds faster than the "sync speed," the window opening between the two curtains is never fully uncovered. Leaf (iris) shutters allow the use of any shutter speed for flash photography. There is no "sync speed" to worry about, since light strikes the entire frame as soon as the shutter starts opening.

On many cameras and on most older cameras, you must manually adjust the shutter speed to the "sync speed" of your camera. These cameras have an "X," lightning bolt symbol, or distinct color differentiation to designate the "sync speed" for that camera.

Dedicated Flash

Many cameras today have "dedicated" flash units that automatically adjust the camera to the "sync speed" when the flash unit is attached, or, if the flash is built into the camera, when the flash is activated.

Flash Exposure

Ifyou have a very old camera, you might have a choice of M, MP, or X synchronization. Make sure the X terminal and setting are used. The M and MP synchronizations are for flashbulbs no longer in use today. Once the shutter speed is set to the "sync speed" of the camera, the only control needed for proper exposure is the f-stop.

sync speed

Manual Flash Exposure

Flash unit manufacturers provide specific "Guide Numbers" for each unit, usually listed on the "specifications" page of the instruction manual. This "Guide Number" varies according to the film ISO. Focus on the subject and divide that distance (shown on the foot/meter scale) into the guide number. The closest f-stop setting or 1/2 stop setting to that number is the f-stop that should be used.

Guide Number (G.N.) = f-stop flash-to-subject distance

Most flash units have a flash calculator dial on the back of the unit. Set the ISO into the calculator, find the flash-to-subject distance, and read the f-stop that aligns with that distance.

Auto-Thyristor

Most flash units have thyristor circuits, which are sensors that receive light from the flash reflected off the subject, and automatically adjust the flash duration for a proper exposure. Each thyristor setting allows the flash to properly light a scene according to the distance the flash has to reach. One setting might allow the flash to light an object anywhere from 5-, a different thyristor setting from 4-15 feet. You can determine the distance the subject is from the camera by focusing on the subject and looking on the foot/meter scale on the lens. Your subject must fall within the range you've set. You may find that more than one auto-thyristor setting is possible for a given shot. The smaller the f-stop you choose, the less distance the flash will be able to throw its light. but the greater the depth-of-field will be. Thyristors work perfectly when the flash is aimed directly at the subject.

Bounce Flash

Many good flash units allow the head of the flash to tilt up or swing to the side, allowing you to "bounce the flash"—reflect it off a secondary surface before striking the subject. This technique softens the light and reduces contrast between highlights and shadows.

To determine the flash-to-subject distance with bounce flash, or the total distance the flash has to travel, calculate the distance of the flash to the reflective surface (ceiling) to the subject. Then use either the calculator wheel or the Guide Number formula. In both cases, open up +1 stop more than the f-stop recommended to allow for light absorption.

Manual Correction

Guide Number (G.N.)

= f-stop + open 1 stop

flash to reflecting surface to subject distance

Experience has shown that when bouncing flash, you should open the lens f-stop 1 to 2 stops more than if it were a direct flash, even though you have a thyristor that supposedly corrects for bounce. The degree of correction depends on how high and how absorbent your ceiling is. A black ceiling would need more than the additional stop of a white reflective ceiling, for example. And a ceiling that's 8 feet away would need less additional light than one at 16 feet away. When bouncing flash, you might expect the thyristor to compensate, since it's going to take the light a little longer to strike the ceiling, then the subject, then return to the sensor. But with most flash systems, correction is needed. The more vertical the bounce, the farther away something is, or the more absorbent the bounce surface, the more light you'll have to let in. Do some simple tests with your flash. Take some bounce flash shots of a Thyristor Correction subject without a correction and then with a +1 f-stop correction. If a dark reflective surface or large flash-to-subject distance is used, test +1 and +2 f-stop increases. The results you get can serve to guide you in the future.

Through-the-Lens (TTL) Flash Metering

A dedicated through-the-lens (TTL) flash system senses the amount of light at the film plane. When the proper quantity of light is "read" off the film itself, the sensor shuts off the flash. The camera must be "dedicated" for TTL to allow a TTL flash to be used. This system allows extremely accurate flash photography, especially when doing "close-ups." When using a "zoom" lens or different focal length lenses, or when using bounce-flash or lens filters, the photographer must make a slight correction to manual and automatic flash photography. TTL solves all those problems, and no corrections are necessary. With "automatic" (thyristor) flash, the sensor is on the flash unit, or possibly the camera body. With TTL, the sensor is at the film, where it gives the most accurate exposure possible.

Red Eye

A phenomenon called red eye occurs in low light with color film and direct flash. Since there is significant pupillary eye dilation in low light, a direct flash will reflect off the retinal blood vessels in the back of the eye. This reflection records in the photograph as red spots or flares. Because their pupils are naturally larger, certain animals, like dogs, will exhibit more obvious red eye. The darker the environment, the greater the potential for red eye, because of greater pupil dilation.

To help prevent red eye, simply increase the ambient light in the room by turning on more lights. The pupils will naturally become smaller, thereby decreasing the red eye effect. You can also try asking the subject to look away from the lens. The most popular remedy, however, is to bounce the flash off the ceiling or a side wall to give a diffused light. Direct flash creates red-eye.

Flash Shadows

One way to deal with harsh shadows cast on a wall behind the subject is to have that subject stand away from the wall. The farther away the subject is from the background's reflective surface, the more diffused the shadow will be. A more effective remedy is to bounce the flash offa wall or ceiling, so the light is more diffuse, has less contrast, and strikes the subject indirectly, giving a more pleasing and natural look. (See Flash-Fill, pg. 95.)

FILTERS

Filters control and modify light before it strikes the film. There are filters for black and white and for color film, and a few can be used for both. Most filters are made of glass and screw onto the front of the lens. There are also dyed gelatin filters called "gels." This type of system uses a separate filter holder that attaches to the front of the lens, allowing for an easy exchange of gels. Although gels are less expensive, they are more fragile, scratch easily, and are not easily cleaned.

The size of the filter mount varies with the size of the lens. Rather than buy a set of filters for all the lenses you own, however, you can buy the largest diameter filter needed and then use inexpensive *adapter rings* to secure the larger filters to the smaller filter mounts.

adapter rings

Standard Filters for All Films

Haze, Polarizing, and Neutral Density filters can be used with all films, both black and white and color.

Haze, skylight, and Ultraviolet (UV) filters are often sold as "protection" filters. They are

"Haze" Filters

clear and offer protection to the front surface of the lens. But if you use a lens cap, as most of us do, why would you also need a clear filter? Only about 90% of the light passes through a clear filter. Furthermore, a clear filter is an inexpensive piece of glass that might even degrade the image.

There is too much fear instilled in us concerning the front surface of a lens. In fact, if you were to slightly scratch the front surface of your lens and then photograph with it, you would not see the scratch or notice any light-scattering effect in the photograph. The scratch is too close to the lens for it to be focused. Repeated scratching would deteriorate the image, but a light scratch or two is virtually impossible to detect.

These filters should be used only for their specific purpose, not for *constant* protection.

It's a good idea to use a UV or skylight filter if you're going to be photographing on water, or near the ocean. Moisture can seep behind the front element and fog the lens. Moisture can also loosen the glues that secure the lens elements in place. Both salt spray and oils from fingerprints on a lens can deteriorate the outer lens coating that helps improve both image contrast and color purity. (See pg. 88.)

Color photographic film is sensitive to ultraviolet light, which is scattered by atmospheric haze. Ultraviolet light has almost no effect on black and white films. With color film there will be a faint blue cast to the image on overcast days or in shadows. A clear (sometimes yellow tinted) "haze" filter called a UV filter will slightly reduce the amount of UV light affecting the film, and the slightly pinkish skylight filter will "warm" the overly bluish cast caused by the ultraviolet light. Neither of these filters has any effect on black and white film. Some filters aren't even designated "UV" or "Skylight," but are simply called generic "Haze" filters.

UV filter

skylight filter

Polarizing Filter

The energy waves of light travel in all directions. When they strike reflective, nonmetallic surfaces (like water, glass, dust, or most any smooth surface), they reflect off in one direction. This reflected light is called "polarized light." A polarizing filter can be thought of as having fine parallel invisible screens within the glass. This filter can be rotated when it is attached to the lens. By rotating the filter, you allow polarized light to travel through the filter or you block it, depending on whether the screens are parallel or perpendicular to the polarized light. Reflections from a store window for example, can virtually be eliminated, revealing the display within. Sometimes you may find that surface reflection or "noise" can add to the impact of a photograph. You decide what you want to show the viewer. It's your creative choice.

DIAGRAM 23 POLARIZING FILTERS

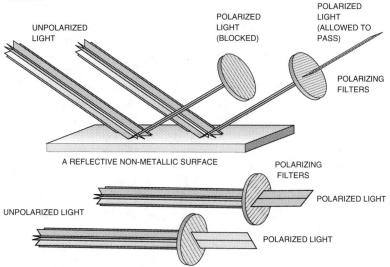

Remember, to block or admit polarized light, you must look through the lens and rotate the filter. If you have an SLR this will be easy, since you're looking through the filter. With a rangefinder, however, you have to put the filter up to your eye, mark the orientation you want,

and then place it on the lens, readjusting it to that orientation.

With distant scenes and landscapes, light sometimes reflects off atmospheric water vapor, which decreases contrast and creates haze. The polarizing filter can cut through this haze in B/W, darken a blue sky, and, with color film, produce color that is richer, deeper, more pure.

With landscapes, maximum polarization occurs when the camera is at a 90 degree angle to the sun. When a polarizing filter is used to remove reflections, a 30 degree angle to the reflecting surface gives the best results.

The filter factor for a polarizing filter is usually 2.5 or an increase of +1 1/3 f-stop. If metering is done through the lens, a correction is automatically made and should be fairly accurate. (See Filter Factor, pg. 82.)

There are two types of polarizing filters: the standard "linear" filter and the more expensive "circular" filter. Most autofocus camera systems *must* use the "circular" polarizer. If your camera uses a beamsplitter or has a semisilvered mirror to determine exposure (as in most autofocus systems), photosensors will receive an improper amount of light through the "linear" polarizer, resulting in improper exposure and possibly poor focus.

Neutral Density Filter

Neutral density filters absorb evenly the wavelengths of all light, without affecting color balance, and therefore reduce the amount of light that reaches the film. They are used in bright light situations, where a slower shutter speed or larger aperture can be used. A 0.15 ND filter reduces light by 1/2 stop; 0.30 ND reduces light by 1 stop; 0.60 ND reduces light by 2 stops; 0.90 ND reduces light by 3 stops.

Filters for B/W Film

Filters are used for contrast control in black and white photographs. They modify

tonal relationships selectively, depending on the color of the subject. Basically, a filter lightens its own color and darkens its complementary color.

The most basic B/W filter is a #8 yellow filter. It is used to render a blue sky the "normal" tone in a B/W print. B/W panchromatic film is sensitive to all the colors that the eye is sensitive to except for blue. Since, blue reproduces a little lighter than it should, beautiful clouds in the sky (for example) might not appear as prominently as they should in the print. A yellow filter is needed to slightly darken a blue sky. An orange #15 filter would render the blue sky darker than normal, and a red #25 filter would make the sky very dark, with very dramatic, almost threatening clouds. Blue and green filters round out the basic B/W filters. A blue filter darkens red or yellow subject matter, lightens sky, and increases the atmospheric effects of haze. A green filter increases the contrast between blue sky and clouds, lightens foliage, darkens flowers and shadows, and accurately renders skin tones. Filter terminology has been standardized with Wratten filter numbers. (Refer to Charts here and on page 80.)

CHART 13 NEUTRAL DENSITY FILTERS

NEUTRAL DENSITY AND POLARIZING FILTERS

NEUTRAL DENSITY (ND)	FILTER COLOR	FILTER FACTOR	F-STOP INCREASE
ND .15	GRAY	1.3	+ 1/2
ND .3	GRAY	2	+1
ND .6	GRAY	4	+2
ND .9	GRAY	8	+3
POLARIZING FILTER	GRAY	2.5	+1 1/3

WRATTEN FILTER#	FILTER I			EXPOS INCRE "STOP	ASE IN
#6	LIGHT YELLOW	1.5		+ 2/3	
#8	MEDIUM YELLOW	2	(1.5)	+1	(+ ² / ₃)
#9	DARK YELLOW	2	(1.5)	+1	(+2/3)
#11	YELLOW- GREEN	4		+2	
#13	YELLOW- GREEN	5	(4)	+2 2/3	(+2)
#15	ORANGE (DEEP YELLOW)	2.5	(1.5)	+11/3	(+ ² / ₃)
#25	RED	8	(5)	+3	(+2 ² / ₃)
#29	DARK RED	16	(8)	+4	(+3)
#47	BLUE	6	(12)	+2 2/3	(+3 1/2)
#58	GREEN	8		+3	
#61	DARK GREE	N 12		+3 2/3	

^{*}Note: In Chart 14, the filters listed in bold type are recommended as the first set of B/W filters to own. The #8 filter is highly recommended.

Numbers in parentheses () indicate the filter factor and exposure increase in "stops" necessary for use under "tungsten" light.

CHART 14 BLACK AND

WHITE FILTERS

Filters for Color Film

Basically, color films are manufactured to respond to a certain color temperature, called the color "balance." The eye adapts well to recognizing colors under all sorts of lighting conditions. But, film is very exacting. Daylight has a very different "color temperature" for film than light from standard tungsten-filament light bulbs. Daylight is "bluer" and cooler than the "yellow-orange" or warmer light of a bulb.

Color films are either "daylight" balanced at 5500K (the most common film used), or "tungsten" balanced at 3200K (Type B) and 3400K (Type A).

There are a few categories of filters for color film: Conversion, Light Balancing, and Color Compensating (CC).

Conversion filters are used to adjust the color temperature of the light source, so it matches the color balance of the film.

When daylight film is used indoors without a flash (a flash is considered daylight balanced), and the source of light is standard tungsten lightbulbs, the orange cast of those bulbs produces an unrealistic orange cast in the photograph. You need to use an 80A filter to convert the color temperature of the light so it matches the film. Likewise, if a "tungsten" balanced film is used outdoors, the photographs come out disturbingly blue. An 85B filter is needed to use "tungsten" film outdoors.

Conversion Filters

Fluorescent lights create a different problem, for they emit a discontinuous light from the spectrum. Fluorescent filters exist to correct the unusually blue-green cast that the light produces in color film (FL-D for daylight film and FL-B for tungsten film). Other light balancing filters, 81 series amber filters, can warm the excessive blue in high UV scenes like snow, high altitude, water and landscapes. Conversely, bluish 82 series filters can be used to "cool" or eliminate the warm quality of early morning or late afternoon light.

Light Balancing Filters

These filters are generally used by professionals for very precise fine tuning in color. Filters exist in red, green, blue, cyan, magenta, and yellow. Each affects specific colors, heightening or reducing their intensity. Certain "professional" films need this type of color correc-

Color Compensating Filters tion to achieve perfect balance. The manufacturers suggest adding specific CC filters, in the instruction sheet they pack with the film.

Filter Factor

Many filters absorb so much light that adjustments must be made in order to achieve proper exposure. Many photographers just meter through the lens with the filter in place, and in most situations that works just fine. Unfortunately, with denser filters the exposure might not be accurate, due to the altered spectral sensitivity of the meter in relationship to the spectral sensitivity of the film. In those cases the filter factor correction is recommended. First, meter without the filter, then place the filter on the lens and adjust the exposure by the filter factor. The factor will differ depending on whether the filter is used under daylight or tungsten (artificial) light. The filter factor is a simple multiplication of the given exposure.

Example:

A given exposure of 1/500 and a filter factor of 2 would be $1/500 \times 2 = 1/250$. In other words, a filter factor of 2 is equal to an increase in exposure of one stop. That increase of one stop could also have been made on the f-stop scale, instead.

IF FILTER FACTOR IS:	INCREASE EXPOSURE THIS MANY STOPS:
1	0
1.2	1/3
1.5	2/3
2	1
2.5	1 1/3
3	1 2/3
4	2
5	2 1/3
6	2 2/3
8	3
10	3 1/3
12	3 2/3
16	4
32	5

CHART 15 FILTER FACTORS

Note: Clear filters need no adjustment. Metering through light-colored filters and polarizing filters also gives excellent results. Metering through dark filters, like a 25 red, will often lead to underexposure because of the absorption of blue light by the filter.

final tips

BATTERIES

There are four types of batteries used in photographic systems. Lithium, Alkaline, Mercury, and Silver Oxide. Lithium batteries rarely leak, and some camera systems require them. But lithium batteries have been traced to improper exposure due to voltage fluctuation. Alkaline and mercury batteries tend to leak, and few of today's cameras use mercury. Silver oxide batteries are the most reliable in cold weather and last longer than alkaline and mercury batteries.

Whether you have a button, AA, AAA, or any specialized photographic battery, you should never touch the battery terminals. Oils from your skin can cause corrosion that affects the electric current. If the batteries have leaked and deteriorated to the point where you see a white "tale" around the gasket or contact points, the battery must be removed immediately. The battery check may still show the battery to be good. The constant gaseous leak causes oxidation build-up between the battery contact and the camera body contact points. If you see a white powder, you can be sure the metal con-

tact points in the battery compartment are corroding. It is more common though, for a battery to look fine but fail to deliver a current. Simple battery problems are the major cause of most trips to the camera repair shop.

A reputable camera repair shop will show you how to deal with oxidation build-up, but here's how to do it. Remove the batteries, and rub all the contact points, including the top and bottom of the batteries, with an eraser. You can use the eraser on a pencil, but the coarse white eraser on the back of a ballpoint pen is even better. On highly corroded contacts, try using an emery board. There is a very good chance the problem will be corrected. Oxidation build-up from the previous batteries occasionally prevents the new batteries from making solid contact. By polishing clean the contact points, the oxidation chemical build-up is removed, and the current can flow. At every battery change (which, to play safe, should be once a year), clean the contact points. And while you're at it, also clean off the contact point on the hot shoe.

If the batteries in your camera should go dead when you're on location or in the field, and new ones are unavailable, try removing the "dead" batteries and cleaning all metal contact points on the batteries and on the contacts with an eraser (or buff hard with cloth material). Replace the batteries, and you may be surprised to find you can get more life from them.

THREE TIPS FOR HAND HOLDING SHOTS

In general, the longer the focal length of a lens, the more difficult it is to hand hold it. Remember, a telephoto lens magnifies everything—it magnifies the size of an object and it magnifies camera movement. It's like good binoculars. No matter how steady you hold them, when you

look through them, you will notice that the scene vibrates as though in an earthquake.

Since any camera movement affects the sharpness of the photograph, it is critical to find a position in which you are most steady. Some photographers hold the camera with one hand under and supporting the lens; others hold onto the sides of the camera. Here are several tips to help you prevent camera movement.

Body Tripod

Always hold your arms so that your elbows are down against your chest. When your arms are out to the side, the lack of support creates muscle tension, which can result in minor camera movement. If you create a tripod with your body, your camera will be held extremely steady. Place your elbows against your chest and the eyepiece of the viewfinder firmly against your skull. If you wear glasses, press the viewfinder firmly against your eyeglass lens, pressing the frames back until no further movement is possible.

Breathing

The second factor is breathing. This is most important. You should release the shutter after you exhale. Before inhaling, your body is at its calmest and therefore the camera can be held steadiest. You never want to photograph while holding your breath, or with your lungs full.

Shutter Release Squeeze

The third factor is the release of the shutter. It is most important to slowly squeeze the button even after you hear it release. Do not jerk your finger down and up.

If you follow these three tips, you should be able to hand hold a shot at a slower speed than any book suggests. There is an old rule of thumb: "Use the shutter speed closest to the focal length of the lens" (1/60 for a 50 mm lens; 1/125 for a 150 mm lens; 1/500 for a 500 mm lens). If you follow these three suggestions and put the camera directly up against your skull, you probably can hand hold up to *two stops* slower speed. If you wear glasses, you can easily hand hold *one stop* slower than usual. Test it out for yourself—you'll be surprised. You might find you can hand hold the camera at even slower speeds.

If you have trouble holding the camera steady, for whatever reason, use a tripod and a cable release.

LENS AND CAMERA CARE

Many photographers today carry their cameras in small camera bags with special compartments for extra lenses, flash units, film, etc. These padded bags protect the camera from physical shock and the weather.

- Avoid storing a camera in excessive heat, as in a car parked in the sun. The heat can cause the lubricants in the camera and lens to seep, causing serious damage.
- ► A short, comfortable neckstrap is highly recommended. The longer the neckstrap, the more the camera will swing and jostle against the body.
- ▶ Never store a manual camera with the shutter cocked.
- ▶ If a camera is not going to be used for a few months, remove the batteries.
- ▶ Try not to touch the surface contact point of the batteries when placing them in the camera or flash. The oil from fingers can cause corrosion of the battery, affecting the proper flow of electric current.
- ▶ In damp environments, don't store cameras in plastic bags for long periods of time. You can use plastic bags for storage for short periods, if you place moisture-absorbing silica gel packets with the equipment.

- ▶ Use a rubber syringe to blow dust from a lens or camera body. Canned air is not "environmentally safe," despite the manufacturers' claims.
- Do not clean a lens unless it is very dirty. To clean a lens, wet a piece of lens tissue with lens cleaner, then rub the surface of the lens gently, using a circular motion. *Never* apply the lens cleaner directly to the surface of the lens. The liquid could seep behind the outer seal and cause condensation within the elements of the lens.

FILM AND X-RAYS

X-rays and airport security systems will affect your film. The higher the ISO rating of the film. the more susceptible it is to damage. X-rays are cumulative, just as they are in the human body. One or two doses might not affect the film, but a number of doses received through various airport screenings can destroy it. Security personnel will usually tell you that x-rays do not affect film. But have they ever asked how many flights and security checks you'll be going through on your trip? Always ask to have your film "hand checked." If necessary, lead lined film bags, available at photo shops, will effectively repel x-rays. But, beware! In high security countries, the officials may increase the xray intensity to the point where they penetrate the lead bag. At that intensity, the film would be instantly "fried"—ruined.

CHANGING FILM IN THE MIDDLE OF A ROLL

With a manual rewind camera, you can change film in the middle of a roll and reuse it later. A motorized camera also permits this if your auto-rewind allows a part of the film leader to protrude from the cassette after rewinding.

Before you remove the half-used roll, note your last frame number. Next, engage the rewind release button and start slowly rewinding. When you reach the beginning of the film, you will hear and feel the leader of the film disengage from the top sprocket of the sprocket wheel. As soon as you feel this release, stop rewinding. At that point, rewind just one-half turn more and open the back of the camera. The leader will be protruding from the cassette, ready for reloading at a later time.

When it is time to reload this roll of film, load it as usual and close the camera. Then place the lens cap on the lens and advance and shoot continuously up to the unused frame. Since no new light has struck the film, all the original exposures are unaffected. To play it safe, add two extra blank shots to avoid any overlap between the last shot (first loading) and the first shot (second loading). Note that on automatic cameras you must have the camera set to Manual to trigger the shutter with the lens cap on!

LABELING FILM

It is a good idea to label film immediately after removing it from the camera. Indicate any personally useful information, such as location, date, or subject. With partially shot film, also include the last frame number. Some photographers carry a roll of masking tape in their camera bag for this purpose. I use removable "stick-on" (i.e., Post-ItTM) file folder labels. They take up less room and they leave no adhesive residue. These labels can also be attached to the camera body or case, and can help those of us who have trouble recalling what was on the first part of a roll of film in a camera not often used.

90

RECIPROCITY FAILURE AND CORRECTION

With very long or very short exposures, the sensitivity of film decreases. There is no longer a reciprocal relationship of exposure time and illuminance to the resulting exposure density on film.

When exposures are longer than 1 second or shorter than 1/2000 second, most films need an increase in the amount of light striking them in order to obtain the required density for proper exposure. Bracketing, making additional, longer exposures around the suggested exposure, is highly recommended for exposures longer than 1 second. Exposure compensation for the extremely short, fast exposures can generally be ignored, but for long exposures, correction is definitely needed.

Each film has its own recommended reciprocity correction. Black and white films are easier to correct because they have one emulsion layer. Color films have three separate emulsion layers. Each of the three layers responds differently to the effects of reciprocity failure. Since specific filtration corrections are needed to compensate for the shifts in color, the film manufacturer's recommendation should be followed. If you want to make an educated guess for color film, bracket around the following suggested corrections for black and white film. (Ideally, the film development time should be reduced, because correcting for reciprocity increases the contrast of film. Shorter film

Bracketing

CHART 16
RECIPROCITY
CORRECTIONS
FOR BLACK
AND WHITE
FILM

INDICATED EXPOSURE TIME:	OPEN APERTURE:	REDUCE FILM DEVELOPMENT TIME:
1 SEC.	1 STOP	10 %
10 SEC.	2 STOPS	20 %
100 SEC.	3 STOPS	30 %

development time reduces contrast. Don't worry if you can't control this.)

RULE OF F/16

An old time rule of thumb states that whenever you are photographing an average scene in direct or overcast light, a good exposure can quickly be made by using f/16 and the reciprocal of the film speed for the shutter speed. Using an ISO 400 film, the shutter would be 1/500 (closest). Using an ISO 125 film, the shutter speed would be 1/125 at f/16 or an equivalent. This is obviously gambling and should be your last resort, though it usually will produce fairly good results.

INFRARED PHOTOGRAPHY

Infrared film is sensitive to some visible light, as well as to the longer wavelengths of infrared. There is a slight difference between infrared focus and visual focus. Infrared (IR) rays are refracted to a lesser extent than visible light, placing the focus behind the film. To correct for this discrepancy, focus as usual on the subject, then rotate the focusing ring until that indicated distance is set opposite the red IR index on the lens (usually a red dot or line).

PUSHING FILM

"Pushing" film means to intentionally underexpose and overdevelop film, usually to allow for shooting in low-light situations (without flash), or for aesthetic reasons. To push film, adjust the ISO setting one or two stops higher (faster) than the film calls for. Pushing one stop means underexposing one-stop; pushing two-stops means underexposing two-stops. The camera will adjust for the higher speed film and therefore require less exposure. For example, to push ISO 400 film one stop, set the ISO to 800. ISO 400 film set to 1600 is pushed two stops.

Some improvement is made to this underexposed film through over-development. The characteristics of pushed film are very poor shadow detail, acceptable mid and high values, and an increase in contrast and grain. Custom labs can usually handle push development of up to two stops.

SUGGESTIONS FOR UNUSUAL AND LOW LIGHT EXPOSURES

Television Screen Photography

With a few precautions, shooting pictures off a television screen or video monitor is quite easy. The only source of light should be the light from the television image. Turn off all lights in the room. Set the camera on a tripod, parallel to the screen. Reduce the contrast of the television image with the contrast control (you want to produce an image that is soft, but with accurate brightness). Set the camera to a shutter speed of 1/15 or 1/30, and use the f/stop indicated by the camera. Since a television beam "scans" the screen at 1/30 of a second, shutter speeds set faster than 1/30 record a diagonal black band because the beam has not had time to complete its cycle. Longer shutter speeds cause the film to record additional scans, which will create a blur or lack of sharpness. With color film, use a CC40R color correction filter on the lens to counteract the green/blue cast of the television.

Low Light, Firelight, and Moonlight Exposures

The following exposures are estimates. Bracketing is required to get acceptable results. For exposures below one second, you will have to correct for reciprocity failure (see pg. 91).

For exposures below one second, you will have to correct for reciprocity failure (see pg. 91).

CHART 17 LOW LIGHT EXPOSURES (ESTIMATED)

EXPOSURE*	LOW LIGHT SITUATION
1/60	Open fire, campfire (recording flames)
1/15	Scene (faces) illuminated by open fire, neon lights, twilight
1/8 - 1/15	Lighted fields (e.g., outdoor sports), brightly lit stage
1/2 - 1/4	Amusement park, fire- works (against dark sky), carnival
1 - 2 SEC	Exterior house lighting, Christmas trees, candelit scene
2-4 MIN 4-8 MIN NA	Moonlit landscape (bright enough to produce shadows, silhouettes) Full 3/4 1/4, crescent
1/30 1/15 1/2	Moon as subject Full 3/4 1/4, crescent

* AT F/8 AT ISO 200

Note: If you use a different f/stop (or shutter speed), either double or halve the exposure time

(or f/stop), following the law of reciprocity (e.g., f/8 at 1/60 = f/11 at 1/30). If you use a film with a different ISO, a change in the above recommended exposures will be required. For every doubling or halving of the film speed a corresponding change of one stop in exposure is necessary. Doubling the film speed requires one stop less exposure; halving the film speed requires one stop more exposure (e.g., f/8 at 1/60 with ISO 200 film = f/5.6 at 1/60 or f/8 at 1/30 with ISO 100 film).

FLASH-FILL

Flash-fill is a technique used in outdoor photography to supplement available daylight. It is helpful when the subject is in deep shade, under a heavy, overcast sky, or strongly backlit or side-lit. By properly balancing the flash exposure one or two stops less bright than the available daylight, texture and detail in the subject become fully visible.

For both automatic and manual flash units, there are various methods that can be employed for flash-fill. You will need to experiment with your specific flash unit to determine a working method for flash-fill. However, there is one sure method for achieving a proper sunto-flash ratio with any camera, which is to set the flash unit to "manual." First, take a meter reading and set the camera to the proper f-stop for a sunlight exposure, using the sync speed as the shutter speed (e.g., f/11 at 1/60). Next, determine the required flash-to-subject distance. Since the fill should be one-stop less bright than the sunlight, choose one f/stop larger (e.g., f/8) and divide it into the guide number (G.N.) of your particular flash unit (e.g., G.N. 80 / f/8 = 10, meaning the flash unit must be 10 feet from the subject). If this distance is unsuitable and the flash must be closer to the subject, use layers of tissue or handkerchief to reduce the light output.

Some flash units have a variable output feature (1/2, 1/4, 1/8, etc.) for manual operation. If you have variable output, put the flash at the distance called for by the f/stop of the original sunlight exposure and set the flash to half power. Remember, always shoot at the original reading for the sunlight exposure.

appendices

ISO	ASA	DIN
4/7°	4	7
6/9°	6	9
10/11°	10	11
12/12°	12	12
16/13°	16	13
20/14°	20	14
25/15°	25	15
32/16°	32	16
40/17°	40	17
50/18°	50	18
64/19°	64	19
80/20°	80	20
100/21°	100	21
125/22°	125	22
160/23°	160	23
200/24°	200	24
250/25°	250	25
320/26°	320	26
400/27°	400	27
500/28°	500	28
640/29°	640	29
800/30°	800	30
1000/31°	1000	31
1600/33°	1600	33
3200/36°	3200	36

APPENDIX 1 ISO / ASA FILM SPEED CONVERSION TABLE

APPENDIX 2 ISO / ASA FILM SPEEDS

Each ISO/ASA film speed number is 1/3 stop faster than the previous one.

6	8	10
12	16	20
25	32	40
50	64	80
100	125	160
200	250	320
400	500	650
800	1000	1250
1600	2000	2500
3200	4000	5000

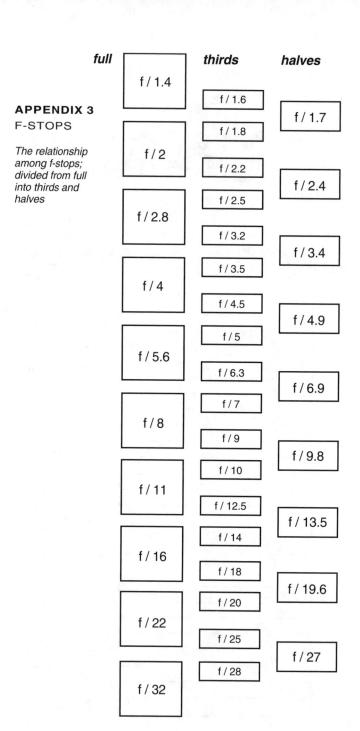

98 appendices

BLACK AND WHITE FILMS

The description of grain is the authors, and does not necessarily correspond to the published information by the manufacturer.

FILM NAME	ISO	GRAIN	FILM CODE
EASTMAN KODAK			
T-Max 100 Professional Plus-X Pan T-Max 400 Tri-X Pan T-Max 3200	100 125 400 400 3200	Very Fine Very Fine Very Fine Fine Medium	TMX PX TMY TX TMZ
FUJI			
Neopan 400 Professional Neopan 1600 Professional	400 1600	Fine Medium	
FORTE			
Forte Pan 100 Forte Pan 200 Forte Pan 400	100 200 400	Very Fine Very Fine Fine	
AGFA			
Agfa APX 25 Agfa APX 100 Agfapan 400	25 100 400	Very Fine Very Fine Fine	
ILFORD PHOTO			
Pan F plus FP4 plus HP5 plus Delta 100 Delta 400 XP2	50 125 400 100 400 400	Very Fine Very Fine Fine Very Fine Very Fine Extremely Fine*	
POLAROID			
PolaPan CT	125	Very Fine **	

^{*} grainless, dye cloud overlap

^{**}Positive Transparency Film, needs special processor

APPENDIX 5

AMATEUR COLOR PRINT FILMS

The following charts list two categories of color negative (print) films and color reversal (slide) films: professional and amateur (standard, over-the-counter) films. Professional films are manufactured under more rigid specifications, with tighter tolerances and narrower latitude. The description of grain is the authors, and does not necessarily correspond to the published information by the manufacturer.

FILM NAME	ISO	GRAIN	FILM CODE
EASTMAN KODAK		7.7 9	00312
Ektar 25 Kodak Gold Plus100 Ektar 100 Kodak Gold Super 200 Kodak Gold Ultra 400 Ektar 1000 Kodacolor Gold 1600	100 100 200	Extremely Fine Extremely Fine Very Fine Medium	CK GA CX GB GC CJ GF
FUJI			
Fujicolor Super G 100 Fujicolor Super G 200 Fujicolor Super G 400 Fujcolor Super HG 1600	100 200 400 1600	Extremely Fine Extremely Fine Very Fine Medium	CN CA CH CU
AGFA			
Agfacolor XRG 100 Agfacolor XRG 200 Agfacolor XRG 400	100 200 400	Very Fine Very Fine Fine	XRG100 XRG200 XRG400
KONICA			
Super SR 100 Super SR 200 Super SR 400 Super SR 3200	200 400	Extremely Fine Very Fine Very Fine Coarse	SR100 SR200 SR400 SR3200
3M			
ScotchColor 100 ScotchColor 200 ScotchColor 400	100 200 400	Extremely Fine Very Fine Fine	ATG 100 ATG 200 ATG 400
POLAROID			
OneFilm	200	Very Fine	

	FILM NAME	ISO	GRAIN	FILM CODE
000000000	EASTMAN KODAK			
	Kodachrome 25 Kodachrome 40 Film 5070 Kodachrome 64 Kodachrome 200 Extachrome Elite 50 Extachrome Elite 100 Extachrome 160 T Extachrome Elite 200 Extachrome Elite 400	25 40 Tungsten (Type A) 64 20 50 100 160 Tungsten 200 400	Extremely Fine Extremely Fine Extremely Fine Fine Extremely Fine Extremely Fine Very Fine Fine Fine	KM KPA KR KL EA EB ET ED
	FUJI			
	Fujichrome 50 Fujichrome 100 Fujichrome 400	50 100 400	Very Fine Very Fine Fine	RF RD RH
	AGFA			
	Agfachrome CT100i Agfachrome CT200	100 200	Fine Fine	CT100 CT200
	KONICA			
	Konica Chrome R-100	100	Very Fine	KR100
	3M			
	ScotchChrome 100 ScotchChrome 400 ScotchChrome 640T ScotchChrome 1000	100 400 640 Tungsten 1000	Very Fine Fine Medium Coarse	-

APPENDIX 7 PROFESSIONAL COLOR PRINT FILM

FILM NAME	ISO	GRAIN	FILM CODE
EASTMAN KODAK			
Ektar 25 Ektapress Gold 100 Vericolor III Ektacolor GPF 160 Ektapress Gold 400 Vericolor 400 Pro 400 Ektapress Gold 1600	25 100 160 160 400 400 400 1600	Extremely Fine Extremely Fine Very Fine Very Fine Fine Very Fine Very Fine Medium	PHR PPA VPS GPF PPB VPH PPF PPC
FUJI			
Fujicolor Reala Fujicolor 160 S Fujicolor 160 L Fujicolor 400 HG	100 160 160 Tungsten 400	Extremely Fine Very Fine Very Fine Very Fine	CS NSP NLP NHG
AGFA			
Agfacolor Ultra 50 Agfacolor Optima 125 Agfacolor Portrait 160 Agfacolor Optima 200 Agfacolor XRS 400 Agfacolor XRS 1000	50 125 160 200 400 1000	Extremely Fine Very Fine Very Fine Very Fine Fine Medium	ULTRA OPT125 XPS OPT200 XRS400 XRS1000
KONICA			
Impressa 50 SR-G 160 SR-G 3200	50 160 3200	Extremely Fine Very Fine Coarse	MP50 SRG160 SRG3200

PROFESSIONAL COLOR SLIDE FILM

FILM NAME	ISO	GRAIN	FILM CODE
EASTMAN KODAK			
Kodachrome 25 Ektachrome Underwater Kodachrome 64 Kodachrome 200 Ektachrome Lumiere 50 Ektachrome Lumiere 50 X Ektachrome 64 Ektachrome 64 X Extachrome 100 Extachrome 100 Plus Extachrome 100 X Ektachrome Lumiere 100 Ektachrome Lumiere 100 X Extachrome Lumiere 100 X Extachrome 160 T Extachrome 200 Extachrome 400 X Extachrome 400 X Extachrome P800/1600	25 50 64 200 50 50 64 64 100 100 100 100 100 100 100 100 100 10	Extremely Fine Extremely Fine Extremely Fine Fine Extremely Fine Extremely Fine Very Fine Very Fine Very Fine Very Fine Very Fine Very Fine Extremely Fine Extremely Fine Extremely Fine Fine Fine Fine Medium	PKM UW PKR PKL LPR LPX EPR EPX EPN EPP EPZ LPP LPZ EPT EPD EPL EES
FUJI			
Fujichrome Velvia 50 Fujichrome 50 D Fujichrome 64 T Fujichrome 100 D Fujichrome 400 D Fujichrome P1600 D	50 50 64 Tungsten 100 400 1600	Extremely Fine Very Fine Very Fine Very Fine Medium Coarse	RVP RFP RTP RDP RHP RSP
AGFA			
Agfachrome RS 50 Plus Agfachrome RS 100 Plus Agfachrome RS 200 Agfachrome RS 1000	50 100 200 1000	Extremely Fine Extremely Fine Very Fine Coarse	RS50 Plus RS100 Plus RS200 RS1000

glossary

A aberration An optical defect in a lens, due to the lens design, that causes blurring or some other type of distortion.

acutance (sharpness) An objective measure of image sharpness. This is tested by placing a knife

edge on the film and exposing it to light.

adapter ring A device attached to the front of a lens to allow a filter or another piece of equipment to be fitted to the lens (e.g., may be used to fit a different size filter to the specific filter thread size of the lens).

American National Standards Institute (ANSI) An organization, formerly called the American Standards Association (ASA), that develops methods of measuring and testing for the purpose of setting standards. For many years ASA was the system used to rate the light sensitivity of photographic materials.

American Standards Association (ASA) See American National Standards Institute.

angle of acceptance See angle of view.

angle of view The area of a scene that a lens (or meter) can cover. Varies with the focal length of the lens.

antihalation backing A coating of dye/pigment on the back of film that absorbs any light penetrating through the emulsion, preventing internal flare or reflection.

aperture An opening, usually in or near a lens, that allows light to enter the camera and strike the film.

aperture priority An Automatic (A) feature that allows the photographer to choose the aperture (f-stop), with the camera automatically selecting the shutter speed.

auto-focus (AF) On certain camera systems, the ability of the camera to automatically focus the lens. **auto-load** A feature used on certain cameras to simplify film loading. The photographer places the film cassette in the film chamber, stretches the leader to a specific mark near the take-up spool, and closes the camera back. The camera automatically engages and winds the film onto the take-up reel. This feature is helpful for those who have difficulty manually threading film onto the take-up reel.

automatic exposure (AE) An automatic metering system that allows the camera to determine and set the aperture, shutter speed, or both. See *aperture priority (AP)*, *shutter speed priority (SP)* and *program mode (P)*.

automatic mode (A) See Automatic Exposure.
auto-rewind On certain motorized cameras, the ability to engage a switch to automatically rewind film from the take-up spool back into the cassette.
auto-thyristor A metering device used to cut off the flash when the proper exposure has been recorded on the film. Usually found inside the flash unit.
auto-wind On certain motorized cameras, the ability of the camera to automatically advance film to the next frame.

available light See existing light.

averaging meter Reflected-light meter that is sensitive to the entire range covered by the lens.

B back light Illumination that comes from behind the subject (shadow is cast forward).

between-the-lens shutter See leaf shutter.

bounce flash Diffused illumination caused by directing head of flash unit away from the subject. The flash may be "bounced" off a card, ceiling, or wall, producing a softer light.

bracketing Intentional over and under exposure on either side of a designated exposure.

bulb (B) A shutter speed setting that allows the shutter to remain open for as long as the shutter release is depressed. Used for long exposures.

C cable release A flexible cable that usually screws into the shutter release button to allow the shutter to be released without touching the camera. Used to

reduce camera movement on long exposures.

camera back 1. The door that swings open on a camera to allow the film to be loaded; usually holds the pressure plate. 2. The part of an interchangeable camera system that holds the film.

camera obscura "Dark room" (Latin). Initially a darkened room with a small hole in one wall which formed on the opposite wall a scene from outside the room. The precursor of the camera as we know it. cassette A light-proof container that holds roll film wound on a spool.

CC filters See color compensating filters.

center-weighted A metering system that "biases" the exposure towards what is in the center of the viewfinder.

chromes See positive film.

circles of confusion The relative size of the points of light reflecting from a subject and projected by a lens. The degree of "sharpness" is relative to the size of the discs, or circles, that these points of light create. close-up A term used for a tightly cropped or composed composition; a photograph in which the subject appears closer than expected.

color balance The accuracy of color film or color prints in matching the colors of the original scene. color compensating (CC) filters These filters are generally used by professionals for very precise and subtle changes in color. Filters exist in red, green, blue, cyan, magenta, and yellow.

color saturation Subjective reference to the density of a color.

contact point A metallic surface that allows the flow of electricity between batteries and pieces of equipment.

contrast The range that exists between extremes. Often refers to the range between the light and dark parts of a scene.

conversion filters Filters used to adjust the color temperature of a light source to match the color temperature of the film, in order to produce a correct color balance.

copy-stand A baseboard with a column and a camera mount, which allows a camera to be moved up or down the column. Usually used when photographing flat work. The baseboard might have extension arms with lights attached, for lighting the subject on the baseboard.

D daylight Natural illumination. A color temperature for

photographic color materials of 5500K.

"dedicated" Used to describe a piece of equipment made for a specific camera model (e.g., dedicated flash).

"dedicated" flash A flash unit made for a specific camera that provides automatic exposure as well as other functions, depending on the camera system.

depth-of-field The range in front of and behind the sharpest point of focus that is acceptably sharp; the range between the nearest and farthest subject distance that is in acceptably sharp focus.

"depth-of-field" mode A setting on some "automatic" cameras that allows the camera to automatically select the aperture needed to record the desired "depth of field."

depth-of-field preview A button or switch that will close the lens aperture to the selected f-stop so that the photographer can preview the "depth of field" before taking a photograph.

depth-of-field scale On some lenses, a scale with f-stop markings located between the f-stop scale and the focusing ring scale. These markings are symmetrically placed on either side of the focusing index mark.

diaphragm A device of overlapping leaves for controlling the size of the aperture, which regulates the amount of light traveling through the lens.

DIN (Deutsche Industrie Norm) A European standard for rating film sensitivity, which is based on a logarithmic progression.

DX code An electrical patch code system on the film cassette that allows certain cameras to automatically set the camera to the correct ISO. The DX code also includes a machine-readable bar code on the cassette and a punched hole raster pattern in the film leader, which processing labs can use for identification of the film.

DX override The ability of some DX cameras to override the automatic DX code setting, changing the ISO.

E18% reflectance The mid-point of the photographic gray scale; Zone V. The percentage of light reflectance to which exposure meters are calibrated.

emulsion The light-sensitive coating on a film or paper base, made of gelatin, silver halide salts, and other chemicals.

equivalent exposure An f-stop and shutter speed

combination that is equivalent to another combination, neither increasing nor decreasing the amount of light necessary for a proper exposure.

existing light The light that exists without supplemental lighting such as strobe flash; available light. **exposure** The amount of light reaching the lightsensitive material, due to the aperture opening (illuminance admitted) and the shutter speed (time). The act of letting light strike the emulsion.

exposure compensation dial An override of the automatic exposure, usually one or two stops over or under the designated "normal" exposure.

exposure index (EI) A numerical numbering system used in measuring the light sensitivity of photographic materials. The lower the EI number, the less sensitive the material is to light. Other systems include ASA, DIN and ISO.

exposure memory lock A feature that allows some automatic cameras to take a meter reading off one part of the scene and use it to determine the overall exposure.

exposure meter See light meter.

F film A transparent, thin, flexible material, which is coated on one side with a light sensitive emulsion. See *emulsion*.

film advance lever A mechanism used to wind fresh film behind the shutter. On most cameras, this lever also advances the film counter number and sets the shutter.

film chamber Area where the film cassette resides in the camera body.

film counter Mechanism that designates the number of "shots" exposed on the roll of film.

film leader In 35mm photography, the half-width of film at the beginning of a roll, which is used for loading the film. Also called "leader."

film speed The sensitivity of film to light, designated by an ISO number.

filter factor A multiplication factor used to determine correct exposure when a filter is mounted on a lens.

filter A glass, gelatin, plastic, or acetate device placed in front of a lens in order to alter the "regular" exposure, usually by selectively absorbing some of the wavelengths of light travelling through it. See also color compensating filters, conversion filters, gelatin filter, haze filters, neutral density filter, polarizing filter, skylight filter, ultraviolet filter.

flash The artificial illumination caused by an electronic flash unit (strobe).

flash-fill The use of a flash unit in outdoor photography to supplement available daylight.

f-number See f-stop.

focal length The distance from the optical center (rear nodal point) of the lens to the plane of sharp focus, when the lens is focused at infinity.

focal plane shutter A shutter built into the camera body as close as possible to the film plane.

focus To make sharp. When film is at the proper focal point for the distance of the object, the image is in focus.

focus-lock A device on auto-focus camera systems that can lock a specific object into focus, to allow a different framing without losing the desired focus target.

focus scale The scale marked with feet/meters on the focusing ring.

focusing index mark A symbol or line on the lens barrel (the center mark, if a depth-of-field scale is present), that points to the distance of the focused object on the focus scale.

focusing ring The part of a lens that moves the lens closer to or farther away from the film plane, in order to make the subject sharp. May have a focus scale on it. **focusing screen** The ground-glass mechanism in the camera viewing system that aids in focusing an image. In certain cameras the focusing screen is interchangeable.

format The dimensions of the film image, determined by the template and film size.

front light Light that casts a shadow behind the subject.

f-stop The number that results from dividing the focal length of a lens by the effective diameter of its aperture. Also called the f-number.

G gelatin filter A thin dyed and lacquered piece of gelatin used as a filter.

gels Slang for gelatin filters.

grain Refers to the size of the clumping of developed silver in a negative.

Guide Number (G.N.) A number rating system for flash units that is used to calculate the f-stop based on film speed and flash-to-subject distance.

H"haze" filters A category of clear filters that include
"UV" and "skylight" filters used to reduce haze and

ultraviolet light (excess blue in color film).

hot shoe A bracket on the top of a camera with an electrical contact point. When a flash unit is mounted on the shoe, the contact point will trigger the flash in sync with the shutter.

hyperfocal distance The distance to the nearest point of focus when the lens is focused at infinity. **hyperfocal focusing** Focusing on the hyperfocal distance, thus creating the maximum possible depth of field.

illuminance The intensity of light falling upon the subject, measured with an incident-light meter.

image size The magnification of the subject created by a lens. Varies with the focal length and subject distance. incident meter A hand-held exposure (light) meter, which measures the amount of light falling upon the

International Organization for Standardization (ISO) The organization that devised the most commonly accepted exposure index (EI) standards. A combination of the ASA and DIN systems.

iris diaphragm See diaphragm.

iris shutter See leaf shutter.

ISO See International Organization for Standardization.

latitude The amount of over and under exposure a film allows with acceptable results.

LCD (liquid crystal display) An electronic display window that can form numbers, symbols, etc. Used in many cameras and meters with digital readout. leader See film leader.

leaf shutter A shutter with overlapping blades that are mechanically or electronically controlled to admit light through the lens for a specific amount of time.

LED (light emitting diode) An electronic flashing light designating information; usually found within the viewfinder.

lens Optical glass (or other transparent material) that forces rays of light to diverge or converge to form an image.

lens barrel The tube of the lens housing the various lens elements.

lens element A single piece of glass that is a lens or part of a compound lens. A compound lens is made of many lens elements.

light The visible part of the electromagnetic spectrum (400-700nm).

light balancing Matching the color temperature of the light source to the color temperature of the film. See *conversion filters*.

light emitting diode See LED.

light meter A device, either built into the camera or separate, that measures the intensity of light present and indicates an f-stop and shutter speed combination for proper exposure, based on the film speed.

liquid crystal display See LCD.

luminance The intensity of light reflecting off or emanating from a subject. Measured with a reflected-light meter.

M" Symbol used for "manual." Also the symbol used on some shutters to designate the setting for M-class flashbulb synchronization (flashbulbs that are rarely in use today).

macro lens Specially designed lens that extends its normal focusing to include close-up photography. Lens designed for optimum image quality, correcting common problems in close-up photography.

manual (M) override On automatic exposure cameras, the ability to override the automatic settings and set exposure functions manually. On auto-focus cameras, the ability to override the automatic setting to manually focus.

manual switch See depth-of-field preview.

matrix meter A meter design that reads light from a myriad sensors and analyzes the information through a microprocessor.

maximum effective aperture The largest or maximum possible f-stop opening of a lens. The speed of a lens.

N neutral density (ND) filter A filter that evenly absorbs the wavelengths of light, without affecting color balance.

normal lens A lens with a focal length that is close to the diagonal of the film plane; a lens that does not magnify or reduce the objects in a scene. Most closely reproduces the scene as viewed by the human eye.

P panning A technique in which the camera is moved along with a moving subject during exposure. The result is that the moving subject remains relatively sharp and the background becomes blurred in the photograph.

parallax error In rangefinder cameras, the angleof-view difference between the viewfinder image and the image the lens records. Significant in close-up and copy-stand photography.

pentaprism The part of the viewing system of single lens reflex cameras that receives the light from the mirror and directs it to the eyepiece.

perspective The relative size of objects in relation to their distance from the camera. Altered by camera to subject distance only.

polarizing filter A filter that polarizes light in order to reduce reflections and glare from non-metallic surfaces.

portrait lens A slight telephoto lens used for head and shoulder portraits.

"positive" film A transparent film that matches the tones or colors of the original scene. Also called color transparency, reversal film, slide film, and "chromes."

pressure plate A spring-mounted plate, located on the camera back, that holds the film flat against the template and parallel to the lens plane.

prism See pentaprism.

program mode (P) An automatic metering function that sets the camera to an f-stop and shutter speed chosen from a pre-determined set of combinations.

R rangefinder An optical device in a viewfinder that focuses the lens by determining the camera-to-subject distance.

rear nodal point In a compound lens, the position from which the focal length is determined; similar to the optical center of a simple lens.

reciprocity correction A specific exposure increase that corrects for reciprocity failure.

reciprocity failure Failure of a film to follow the reciprocity law. This occurs in very long or very short exposures.

reciprocity law When Exposure (E) = Intensity (I) x Time (T). This reciprocal relationship allows for equivalent exposure settings.

red eye A red spot in the center of the eyes of people or animals. This occurs in photographs when the light rays from the flash unit reflect off the blood vessels of the retina.

reflected-light meter A light meter that reads the light reflecting off or emitted from the objects in the field.

relative motion The apparent speed of a moving

object, based on actual speed, distance, and direction. **resolving power (resolution)** The ability of a film to reproduce fine detail.

revealing light The broad, diffused light that exists on an overcast day, or the light cast by fluorescent lights. Shadows are evenly dispersed.

reversal film See positive film.

rewind crank Mechanical gear used to rewind film from the take-up spool back into the film cassette. **rewind release button or switch** Disengages the sprocket wheel gear, allowing the film to rewind.

rule of f/16 A method of estimating an exposure at f/16, if no light meter is available.

S self-timer A mechanism (usually built into the camera) that delays the operation of the shutter for a few seconds after the shutter release button has been "tripped."

shoe A bracket that is used to attach a flash unit to a camera, bracket grip, or other device. See *hot shoe*. **shutter** A mechanism that opens and closes at a controlled interval of time, allowing light to expose the film in the camera.

shutter release button The "trigger" or lever that, when depressed, allows the shutter mechanism to operate.

shutter speed The designated length of time for an exposure, indicated by the marking selected on the shutter speed dial.

shutter-speed priority (SP) An automatic camera operating mode. When using SP, the photographer sets a shutter speed and the camera automatically selects the appropriate f-number for correct exposure. **side light** A directional light that casts a shadow to one side of the subject.

silver halide A compound of silver and halogen salt, which is the light-sensitive substance in photographic emulsions.

single-lens reflex (SLR) A type of camera that allows the photographer to view and compose through the lens by means of a mirror-prism system.

skylight filter A filter that reduces excess blue in color films. Often used as a lens protector. See *haze filters*.

slide film See positive film.

spectral sensitivity The degree or range of sensitivity of film to visible light on the electromagnetic spectrum.

"speed" (of a lens) See maximum effective aperture.

spot meter A light-meter that uses a very narrow angle of light for its sensor.

sprocket wheel Engages the film's sprocket holes in order to pull fresh film forward.

stop A change of either half or double the preceding exposure, in either the aperture or the shutter speed. **sync cord** A special cord (PC cord) that makes the electrical link between a flash unit and a camera body, by connecting the flash unit to the sync

sync speed The fastest shutter speed on a focal plane shutter camera that allows for flash synchro-

synchronization (sync) terminal The receptacle on the camera body for the PC terminal of the sync cord.

T take-up spool The mechanism on which the "exposed" film is wound.

"taking" lens The lens that records the image on the film.

teleconverter An attachment that fits between the lens and the camera body, effectively increasing the focal length of the lens.

telephoto lens A general term for a lens whose focal length is longer than the diagonal of the film. A lens that is longer than a "normal" lens.

template The rectangular window in the camera body near the focal plane, which creates the format size of the film.

through-the-lens (TTL) The measuring of light after it passes through the lens.

through-the-lens (TTL) flash metering A sensor at the film plane in dedicated flash systems, which shuts the flash off when it senses the proper quantity of light.

thyristor circuit The electronic switch that automatically shuts down the flash when proper exposure has been achieved, and stores the saved power in the capacitor.

time exposure Generally refers to any long exposure that needs to be timed manually. Time exposures are usually longer than one second.

transparency film See positive film.

tripod A three-legged adjustable stand for support of a camera, usually with a tilting and swivelling platform (head) on which the camera is secured.

tripod mount The threaded receptacle on the bottom of a camera, which is used to secure the tripod screw.

tungsten light Light produced by photographic incandescent lamps with a 3200K or 3400K color temperature. Also, a general term for standard filament lightbulbs.

U ultraviolet (UV) filter A filter that reduces the amount of ultraviolet light striking the film.

V viewfinder The complex viewing system that allows for focusing and composing the photograph.

W wide angle lens A lens whose focal length is shorter than the diagonal of the film plane. A lens that is shorter than a "normal" lens.

Wratten filter numbers The most widely used number system for describing and identifying filters.

X x-rays A part of the electromagnetic spectrum that can have a detrimental effect on film emulsion.

Z zone In the zone system, the tone or luminance of a subject when rendered in the print. Each zone from 0-IX is a one-stop difference from its adjacent zone.

zone focus A method of determining the specific depth-of-field by selecting the near and far boundaries of focus.

zone system A method of exposure and development, and a way to describe the tonal translation of a subject's luminance to its corresponding print density.

Zone V In the *zone system*, the mid-gray value of 18% reflectance.

zoom lens A lens that has a continuous selection of focal lengths within its designated range.

index

A	
"acceptable" sharp focus 41	bulb. See "B"
adapter ring 75	
angle of acceptance. See angle of	C
view	cable release 13
angle of view 20, 21, 22, 23	camera
ANSI 52	35 mm 3
antihalation 52	auto-load 9, 10
aperture 3, 13, 19, 26	auto-wind 9
Aperture-priority (AP) 32, 66	autofocus (AF) 19, 20
ASA 11, 52, 53, 54, 97	camera obscura 3
auto-rewind 12	classification 4
auto-thyristor 72	disk camera 16
auto-wind 15	manual load 9
autofocus (AF) 19, 78	rangefinder 4, 6, 7, 8, 77
camera 20	simple camera 4
lens 19, 20	single-lens reflex (SLR) 4, 6, 8
Automatic (A) mode 66	SLR 77
	viewfinder 4
В	camera bag 88
"B" 17	camera care 88
back light 57, 59, 69, 70	camera format 4
batteries 85, 88	camera movement 14
battery chamber 8	cassette 9
between-the-lens shutter 15, 16	cellulose ester 51
body as tripod 87	chromes 69. See film
bounce flash 58, 73	circles of confusion 41
bracketing 91, 93	color balance 56, 80, 81

index 117

color saturation 56	color slide 101, 103
color temperature 80, 81	"daylight" 81
	emulsion 51
D	grain 51, 53
depth-of-field 40, 43, 44, 45	infrared 92
depth-of-field preview 13, 46	leader 9
depth-of-field scale 41, 42, 44, 49	loading 9, 10
diaphragm 25	reloading 89
DIN 52	sensitivity 10, 29, 52
DX bar code 11, 53	static electricity 12, 13
DX code 55	structure 51
DX override 55	"tungsten" 81
	x-rays 89
E	film advance lever 3, 8, 9, 14, 15
18% reflectance 61. See middle	film chamber 8, 9
gray; Zone V	film contrast 56
electronic flash 8	film counter window 15
equivalent exposure 34, 35, 36	film plane 15, 27, 41
exposure 10, 34	film resolution 56
firelight 93	film rewind crank 10
low light 93	film rewinding 11, 12, 89
moonlight 93	film speed 29, 53, 97
television screen 93	film storage 54, 88
unusual 93	filter factor 82, 83
exposure compensation dial 55, 69	filters 75
exposure index (EI) 52	black and white 75
exposure memory lock 30	color 75
exposure meter 69	color compensating 81
averaging 30	conversion 81
built-in 10, 29	fluorescent 81
center-weighted 30	for b/w film 78, 80
hand-held 29	for color film 80
incident-light 29	gels 75
matrix 30	haze 75
reflected-light 29	light balancing 81
spot 30	neutral density (ND) 75, 78, 79
	polarizing 75, 77, 79
F	skylight 75
f-number 25, 26, 43, 69. See also	ultraviolet (UV) 75
f-stop	fish-eye lens 22
f-stop	flash 8, 14, 71
13, 25, 26, 27, 34, 49, 69, 98	bounce 58, 73
f-stop ring 19	dedicated 14, 74
f-stop scale 98	exposure 71, 72
film 3, 9, 51, 52, 53, 55	exposure corrections 73
black and white 99	flash-fill 95
characteristics 56	red eye 74
color print 100, 102	shadows 75

through-the-lens (TTL) 74	image size 20
flash calculator dial 72	nodal point 19
fluorescent light 60, 81	lens cap 76
focal length	lens care 88
6, 19, 20, 24, 26, 43, 44	lens plane 9
focal plane shutter 8, 15, 16	lens tissue 89
focal point 43	lens types 21
focus lock 20, 48	fish-eye 22
	macro 24
focusing index mark 41, 42, 46, 47	
focusing ring 19, 48	normal 21, 22
focusing screen 4, 5	portrait 24
format 4	telephoto 21, 22, 23
front light 57, 58, 69	wide angle 22
	zoom 21, 23
G	light direction 57
gelatin 51	light direction correction 68, 70
gels 75	Light Emitting Diode (LED) 31
grain 51, 56	light meter. See exposure meter
guide number (G.N.) 72, 73, 95	Liquid Crystal Display (LCD) 31
	long lens. See telephoto lens
H	low light exposure 93
halves and doubles 33, 54. See f-	luminance 29
stop; film, speed; reciprocity	
law; shutter speed	M
hot shoe 8, 14	"M" 46, 71
hyperfocal distance 45	macro lens 24
hyperfocal focus 45	manual (M) override 32
Typerrocal rocas 40	manual rewind crank 12
1	manual switch 13
	maximum effective aperture 28. See
illuminance 30	lens speed
image size 20	meter. See exposure meter
incident-light 29	middle gray 61, 64. See 18%
infrared film 92	reflectance; Zone V
IR index 92	mirror 5, 6, 7, 46
iris shutter 15, 16, 71	motion 37, 39
ISO 11, 52, 53, 72, 92, 97	MP 71
L SA	N
latitude 56	
leader 9	nodal point 19, 27
leaf shutter 8, 15, 16, 71	normal lens 21, 22
LED 6	_
lens 3, 6, 19. See focal length	P
angle of view 20	panning 40
autofocus (AF) 19, 20	parallax error 7
barrel 19	PC cord. See sync cord
element 19, 23	perspective 25

index 119

plane of sharp focus. See focal plane
polarized light 77
polarizing filter 77, 78
circular 78
linear 78
portrait lens 24
positive film 69. See film
pressure plate 8, 9
prism 4, 5
Program (P) 32, 66
pushing, film 92

R

rangefinder camera 4, 6, 7, 8, 77 reciprocity correction 91 reciprocity failure 91, 93 Reciprocity Law 34 red eye 74 reflected-light 29 reflex mirror 4 relative motion 37 revealing light 57, 60, 69, 70 reversal film 69. See film rewind crank 8, 9, 10, 12 rewind release button 8, 10, 12 rule of f/16 92

S self-timer 14 sharpness, film 56 shoe. See hot shoe short lens. See wide angle lens shutter 3, 6, 15 between-the-lens 15, 16 focal plane 8, 15, 16 iris 15, 16 leaf 8, 15, 16 shutter mode switch 16 shutter release 87 shutter release button 13, 14, 16 shutter speed 16, 17, 34, 37, 38, 49 shutter speed dial 16 shutter speed scale 18 shutter speed stop 17 Shutter-speed priority (SP) 32, 66 side light 57, 58, 69

silver halide 51
slide film 69. See film
SLR (single lens reflex) 4, 6, 7, 8, 77
sprocket wheel 8, 9, 10, 15
sprocket wheel release 12
"stop" 33, 64
stop action. See relative motion
sync (synchronization)
cord 14
speed 8, 71
terminal 14

T

take-up spool 8, 9, 12, 15 teleconverter 24 telephoto lens 21, 22, 23, 25 template 8, 9, 15 through-the-lens (TTL) flash 74 thyristor. *See* auto-thyristor tripod 14 tripod mount 8, 13

V

viewfinder 3, 4, 7, 8, 13 composition 4 focusing 4 viewfinder camera 4

W

wide angle lens 22, 25 Wratten filter 79

Χ

"X" 71 x-rays 89

Z

zone focus 46, 47, 48 zone placement 65, 68, 70 zone scale 62 zone system 61, 62, 63 Zone V 64. See 18% reflectance; middle gray zone values 63 zoom lens 21, 23